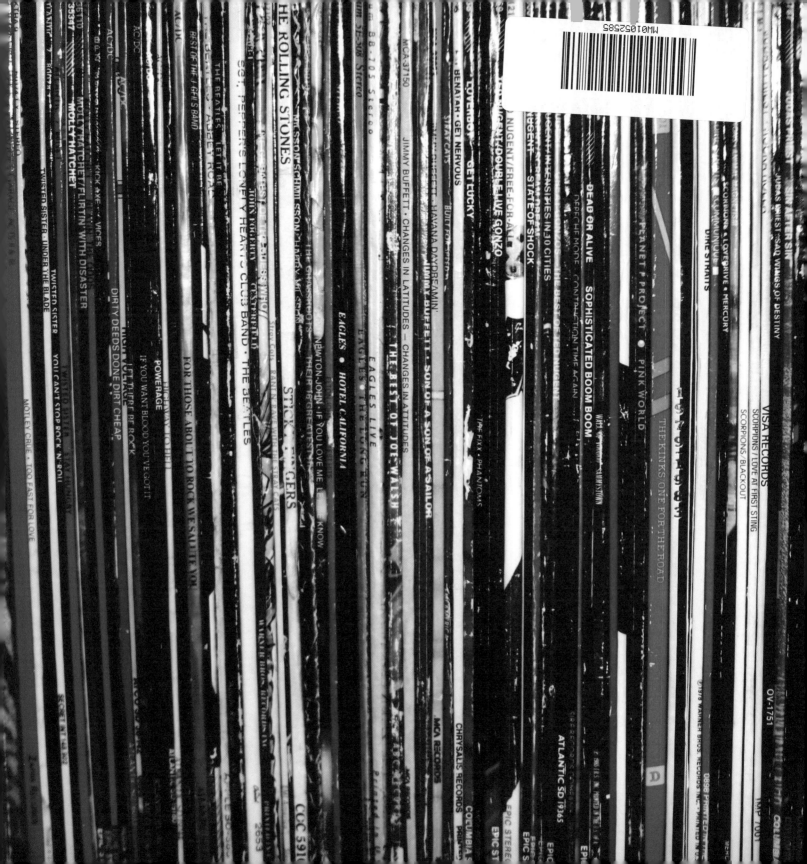

CELEBRITY VINYL

Celebrity Vinyl
by Tom Hamling

A portion of the proceeds goes to 826LA.

Photography: Jonah Light
Design: Eliane Lazzaris
Editing: Buzz Poole
Typefaces used: Eurostile, MetroDF, Ubuntu

Library of Congress Control # 2007937346

Printed and bound IN CHINA THROUGH ASIA PACIFIC OFFSET

10 9 8 7 6 5 4 3 2 1 First edition

This edition © 2008
Mark Batty Publisher
36 West 37th Street, Penthouse
New York, NY 10018

ISBN-10: 0-9795546-2-4
ISBN-13: 978-0-9795546-2-9

Distributed outside North America by:
Thames & Hudson Ltd
181A High Holborn
London WC1V 7QX
United Kingdom
Tel: 00 44 20 7845 5000
Fax: 00 44 20 7845 5055
www.thameshudson.co.uk

BY TOM HAMLING

CELEBRITY VINYL

MARK BATTY PUBLISHER | NEW YORK

Hello. Nice to meet you.

Welcome to *Celebrity Vinyl*. What you hold in your hands is not a study in pop culture. Or kitsch. Or really even music, for that matter. It's a study in the consecration of fame. An examination of the veneration of the C-List.

There's no question the music on these albums is comical. The cover art — ridiculous. But the true humor in this collection lies in the unseen. The back-room discussions. The false "thumbs up" of a sound engineer. And the confusion surrounding those first few royalty checks.

While the majority of my collection falls in the 1970s (LSD) and 1980s (cocaine), a closer chronological look will reveal that this collection spans thirty-three years. Meaning celebrities and their egos do not change, even though the size of their belt buckles might. A celebrity ego is always a celebrity ego. Ed McMahon begets Burt Reynolds; Burt Reynolds begets Terry Bradshaw; Terry Bradshaw begets Alyssa Milano. And so it goes.

Yet we continue to feed the monster. At last count, eighty-four "people" have given Paris Hilton's new CD a 5-star review on Amazon.com. Not getting enough of Kevin Bacon in those Hanes commercials? Go see him play the bongos. Like Allen Iverson's crossover dribble? Just wait until you hear him rhyme. Addicted to freckles and booger sugar? Check out Lindsay Lohan. This is all unforgivable stuff.

TH

CONTENTS

THE BIRTH OF A COLLECTION

In 1999, while writing for an increasingly antiquated advertising agency, a prophetic email came across my screen. It was addressed to "New York - All Staff."

As a rabid fan of the all-office email (Dirty Kitchen!, Alarm Not Set this Weekend!, No Hot Water on 37th Floor!), I'm mad at myself for somehow losing or erasing this one. If memory serves, it kinda looked something like this:

> To: New York – All Staff
> From: Production Department
> Nov 17, 1999 4:32 PM
>
> Attention Staff –
>
> In an effort to valiantly charge into the new millennium, we are updating our entire, in-house music library. In essence, we are going from vinyl records and cassette tapes to compact discs (CDs). Needless to say, this is a huge but necessary undertaking that better prepares us for the upcoming digital age.
>
> This said, we have a huge inventory of records and tapes that we need to get rid of by the end of the year. If you are interested in taking home a piece of the past, come down to the southwest corner of the 39th Floor sometime after 5:00 PM tonight.
>
> Thanks,
>
> Some Old Person About To Get Fired

At 5:05 PM, I owned Bruce Willis – *The Return of Bruno*.
At 5:13 PM, I owned Ethel Merman – *The Ethel Merman Disco Album*.
At 7:49 PM, I owned Shaquille O'Neal – *I'm Outstanding*.

Eight years later, I have somewhere around 120 of these things. I feel like I've done an okay job of emptying most of the world's record stores. But there's work to be done. Sometimes I feel like Dr. Richard Kimble in search of the one-armed man. Except my one-armed man is the inaudible shriek of Jennifer Love Hewitt.

Worst collection ever.

The Author

If man makes himself a worm, he must not complain when he is trodden on.
Immanuel Kant - 18th Century German Philosopher

10

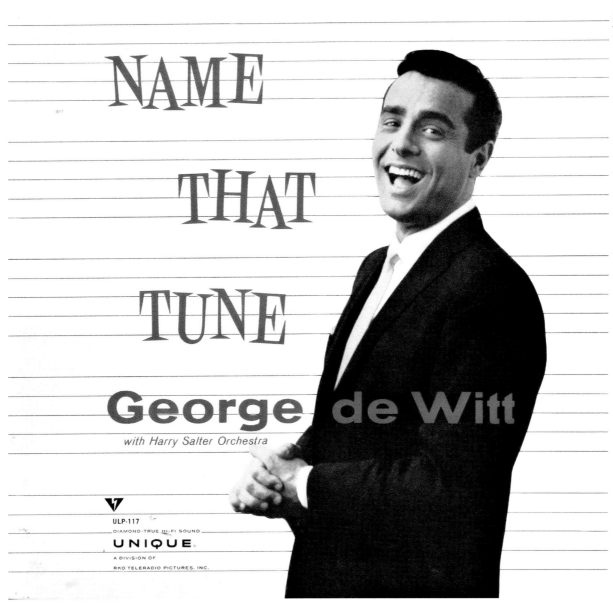

GEORGE DE WITT —— Name That Tune

I can name all these crap tunes in one note.

DL 8410

JERRY LEWIS

Just Sings

Printed in U.S.A.

 ——— Just Sings

All things considered, this is probably the
funniest thing this man has ever done.

MR. MAGOO — Magoo in Hi-Fi

I wish Mr. Magoo was Andy Capp. Because then there'd be Hot Fries for me to eat as I watched him slowly drink himself to death.

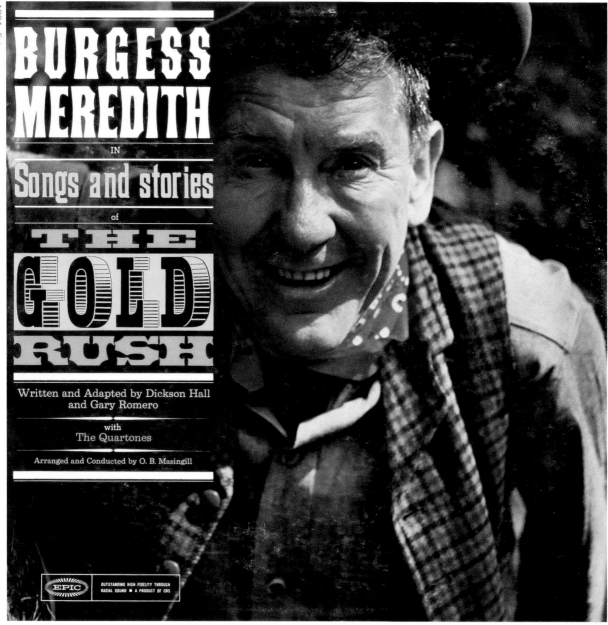

1961 - Epic

13

BURGESS MEREDITH ——— Songs and Stories of The Gold Rush

Ahh, the gold rush. Is there an era in history that's more deserving of a musical tribute?

Possible titles out there that could be more random than this include:
• Manute Bol - "Fibs and Riddles of the Holocaust"
• Paula Poundstone - "Tales and Tunes of the Inquisition"
• Eddie the Eagle – "Bronze Age Jock Jamz"

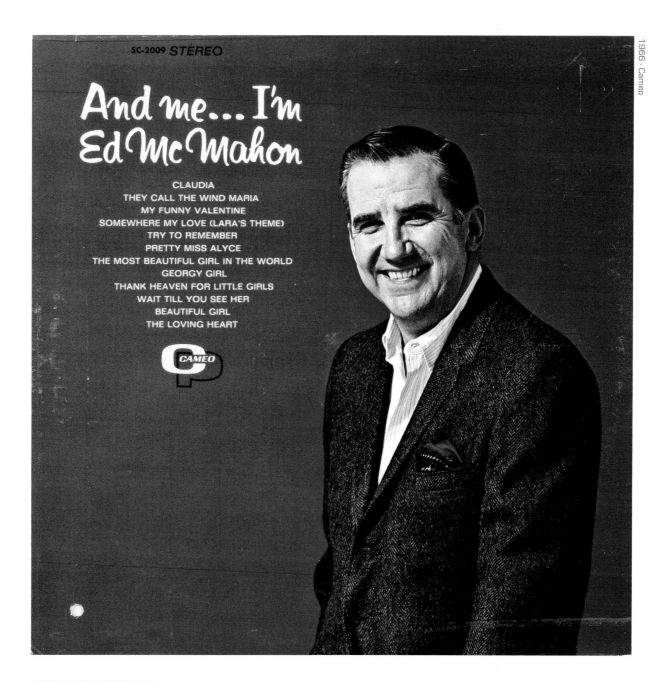

SC-2009 STEREO

1966 · Cameo

And me... I'm Ed McMahon

CLAUDIA
THEY CALL THE WIND MARIA
MY FUNNY VALENTINE
SOMEWHERE MY LOVE (LARA'S THEME)
TRY TO REMEMBER
PRETTY MISS ALYCE
THE MOST BEAUTIFUL GIRL IN THE WORLD
GEORGY GIRL
THANK HEAVEN FOR LITTLE GIRLS
WAIT TILL YOU SEE HER
BEAUTIFUL GIRL
THE LOVING HEART

CAMEO CP

ED MCMAHON ——————— And Me...I'm Ed McMahon

Hey-ooooo!!!!!!!!! This pre-Betty Ford masterpiece really
defines an era. An era of creepiness. An era where
numerous grown men felt compelled to sing the song
"Thank Heaven for Little Girls." The version on this
album must be to pedophiles what jean shorts are to
people in the Las Vegas airport.

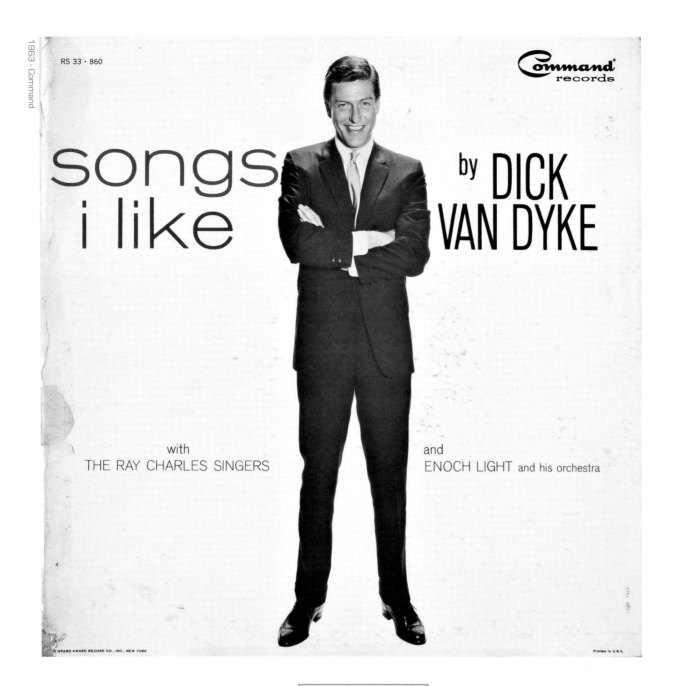

RS 33 · 860

Command
records

songs
i like

by DICK
VAN DYKE

with
THE RAY CHARLES SINGERS

and
ENOCH LIGHT and his orchestra

GRAND AWARD RECORD CO., INC., NEW YORK

Printed in U.S.A.

DICK VAN DYKE ——— Songs I Like

Without question, the worst Scooby-Doo episode ever was the one where Dick Van Dyke worked for the haunted carnival. Way to know your target demo, Hanna-Barbera.

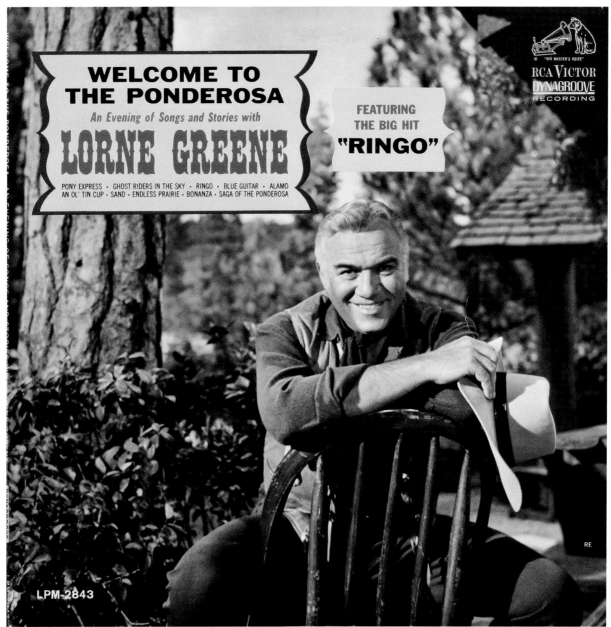

WELCOME TO
THE PONDEROSA

An Evening of Songs and Stories with

LORNE GREENE

PONY EXPRESS · GHOST RIDERS IN THE SKY · RINGO · BLUE GUITAR · ALAMO
AN OL' TIN CUP · SAND · ENDLESS PRAIRIE · BONANZA · SAGA OF THE PONDEROSA

FEATURING
THE BIG HIT
"RINGO"

1964 - RCA Victor

RCA VICTOR
DYNAGROOVE
RECORDING

"HIS MASTER'S VOICE"

LPM-2843

RE

LORNE GREEN
Welcome To The Ponderosa

Now here's a man you can hang your hat on. Ain't no
use criticizing a man like Ben Cartwright. After about
29 minutes of it, you'd realize you were wrong and
learn a valuable lesson about fairness and integrity.
Then Hop Sing would say something funny.

The Man

God damn, Lorne Greene can kick some ass. Denim on suade on tweed. Good fucking luck pulling that off. All aboard the 1 Train. Next stop - your face.

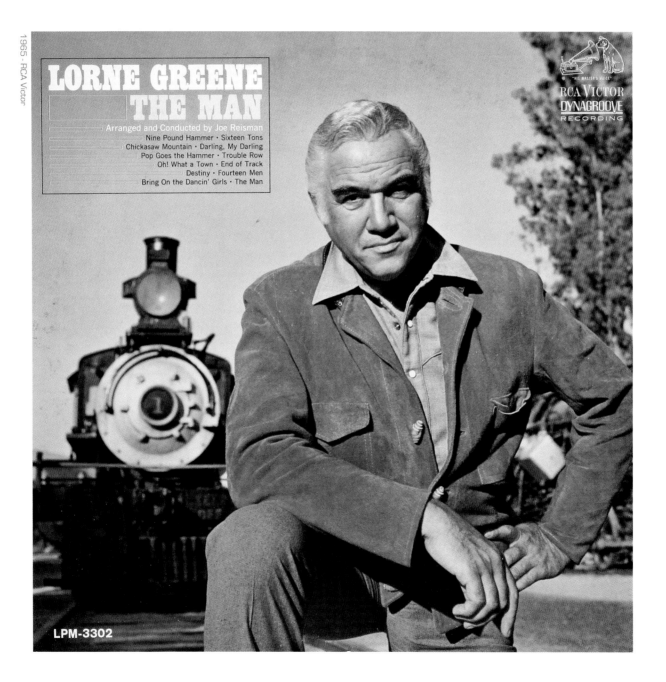

LORNE GREENE THE MAN

Arranged and Conducted by Joe Reisman

Nine Pound Hammer • Sixteen Tons
Chickasaw Mountain • Darling, My Darling
Pop Goes the Hammer • Trouble Row
Oh! What a Town • End of Track
Destiny • Fourteen Men
Bring On the Dancin' Girls • The Man

RCA Victor
DYNAGROOVE
RECORDING

LPM-3302

17

The Beverly Hillbillies

Thank God Hal Holbrook does an absolute spot on impersonation of Mark Twain. Otherwise, the South would have some serious stereotype issues right now.

18

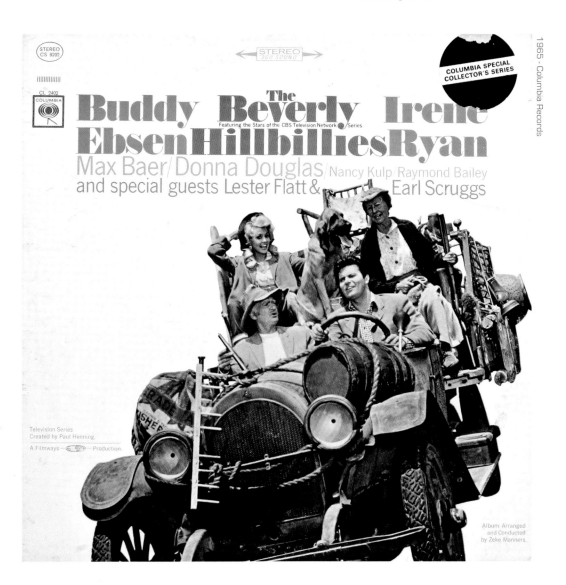

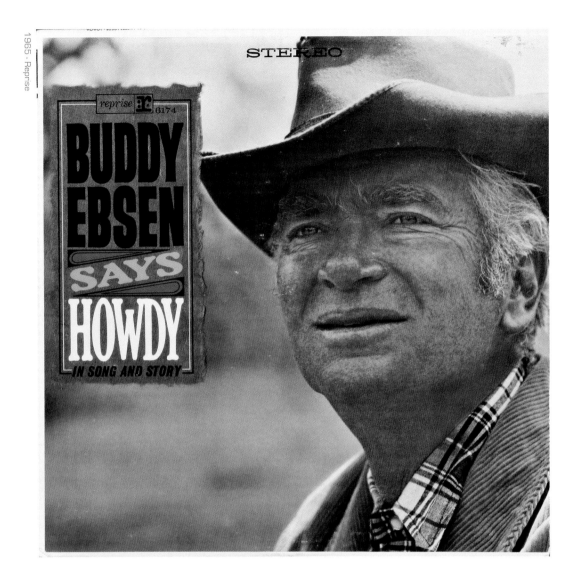

STEREO

reprise 6174

BUDDY EBSEN SAYS HOWDY IN SONG AND STORY

BUDDY EBSEN ———————— Buddy Ebsen Says Howdy In Song And Story

Do you think that Buddy and Burgess Meredith ever got together and compared their horrible decisions?

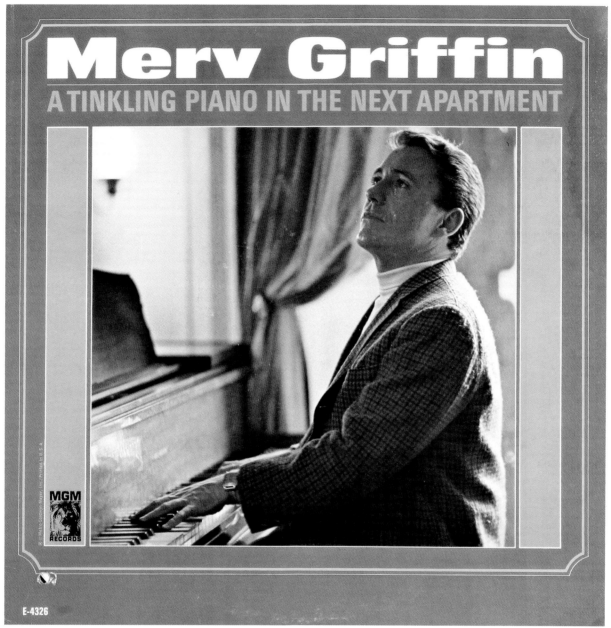

20

Merv Griffin
A TINKLING PIANO IN THE NEXT APARTMENT

MGM RECORDS

E-4326

MERV GRIFFIN ——— A Tinkling Piano In The Next Apartment

Quick. Somebody call a hospital! Merv Griffin
has gone blind! Merv Griffin has gone blind!
The tinkling piano in the next apartment
belongs to a blind man!

How Sweet It Is For Lovers

Hi, I'm Jackie Gleason. Let me sing for you. Let me wear a red carna-
tion for you. Let me smoke a cigarette for you. Is it just me or does
this Jackie Gleason seem like a much better father than the Glea-
son who neglected his little, racist son in *The Toy*? FYI – after *The
Toy*, that kid went on to become a porn star and starred in some
classics: *Skin Walker, The Wrong Snatch* and *New Wave Hookers
5*. It looks like that little sexual heart-to-heart he had with Richard
Pryor at the park didn't quite sink in. Wasn't he sitting on a canon
or something?

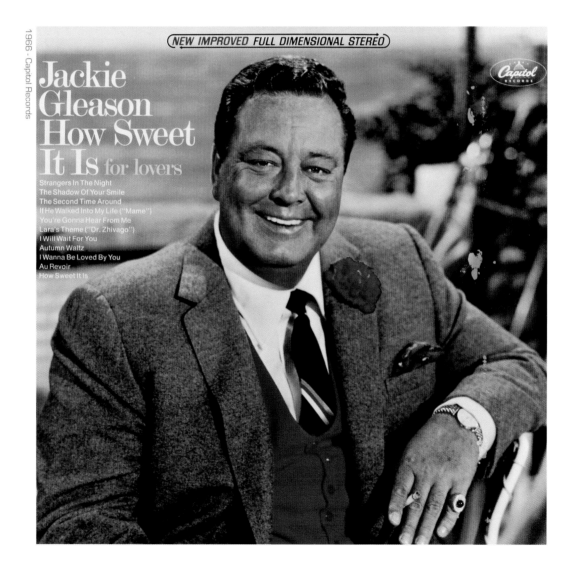

1966 - Capitol Records

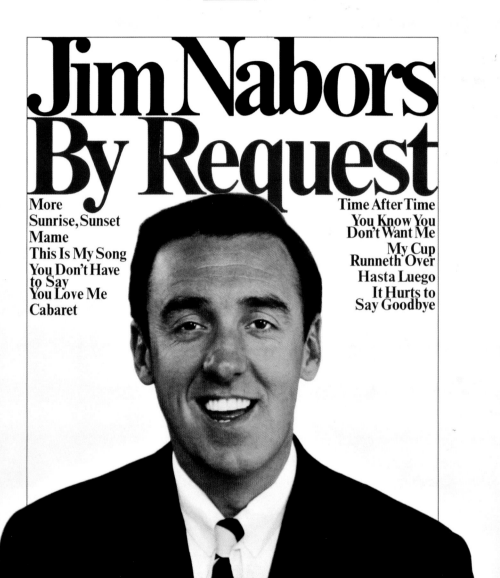

STEREO
360 SOUND

Jim Nabors By Request

More
Sunrise, Sunset
Mame
This Is My Song
You Don't Have
to Say
You Love Me
Cabaret

Time After Time
You Know You
Don't Want Me
My Cup
Runneth Over
Hasta Luego
It Hurts to
Say Goodbye

1966 - Columbia Records

22

JIM NABORS —————— By Request

No surprise, surprise, surprise. Gomer went
to the University of Alabama.

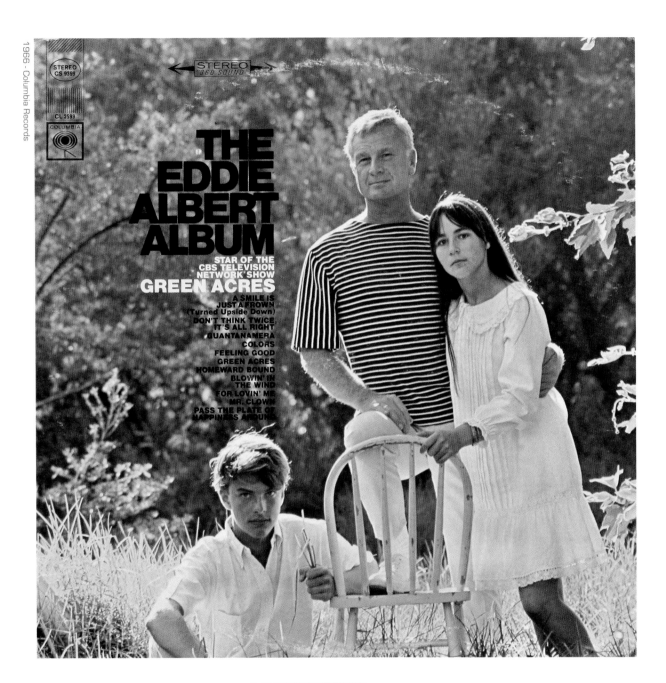

STEREO
CS 9399

CL 2599

COLUMBIA

STEREO
360 SOUND

THE EDDIE ALBERT ALBUM

STAR OF THE
CBS TELEVISION
NETWORK SHOW
GREEN ACRES

A SMILE IS
JUST A FROWN
(Turned Upside Down)
DON'T THINK TWICE,
IT'S ALL RIGHT
GUANTANAMERA
COLORS
FEELING GOOD
GREEN ACRES
HOMEWARD BOUND
BLOWIN' IN
THE WIND
FOR LOVIN' ME
MR. CLOWN
PASS THE PLATE OF
HAPPINESS AROUND

23

EDDIE ALBERT ──────── The Eddie Albert Album

Ahoy sailor. All aboard the S.S. Creepy.

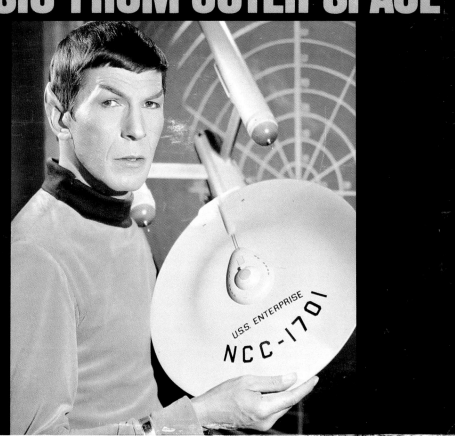

LEONARD NIMOY — Mr. Spock's Music From Outer Space

What nerds listen to on prom night as
they silently cry themselves to sleep.

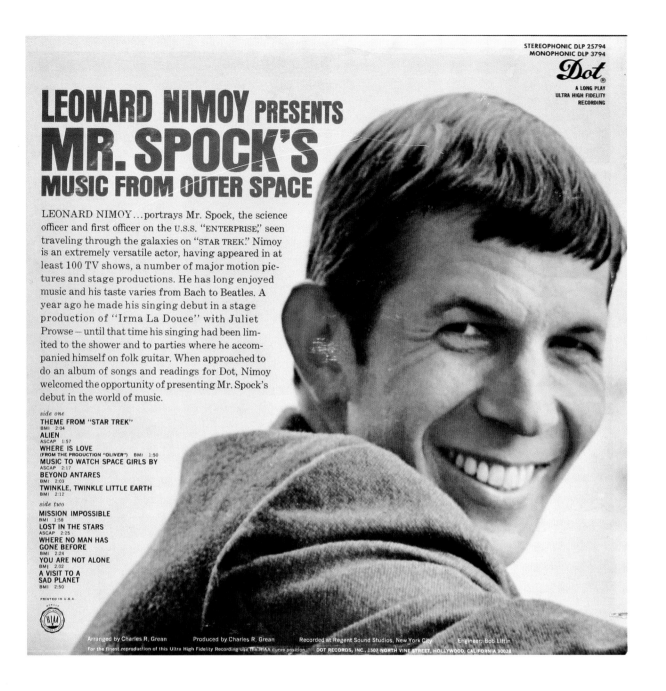

STEREOPHONIC DLP 25794
MONOPHONIC DLP 3794

Dot®

A LONG PLAY
ULTRA HIGH FIDELITY
RECORDING

LEONARD NIMOY PRESENTS
MR. SPOCK'S
MUSIC FROM OUTER SPACE

LEONARD NIMOY…portrays Mr. Spock, the science officer and first officer on the U.S.S. "ENTERPRISE," seen traveling through the galaxies on "STAR TREK." Nimoy is an extremely versatile actor, having appeared in at least 100 TV shows, a number of major motion pictures and stage productions. He has long enjoyed music and his taste varies from Bach to Beatles. A year ago he made his singing debut in a stage production of "Irma La Douce" with Juliet Prowse — until that time his singing had been limited to the shower and to parties where he accompanied himself on folk guitar. When approached to do an album of songs and readings for Dot, Nimoy welcomed the opportunity of presenting Mr. Spock's debut in the world of music.

side one
THEME FROM "STAR TREK"
BMI 2:04
ALIEN
ASCAP 1:57
WHERE IS LOVE
(FROM THE PRODUCTION "OLIVER") BMI 1:50
MUSIC TO WATCH SPACE GIRLS BY
ASCAP 2:17
BEYOND ANTARES
BMI 2:03
TWINKLE, TWINKLE LITTLE EARTH
BMI 2:12

side two
MISSION IMPOSSIBLE
BMI 1:58
LOST IN THE STARS
ASCAP 2:25
**WHERE NO MAN HAS
GONE BEFORE**
BMI 2:24
YOU ARE NOT ALONE
BMI 2:02
**A VISIT TO A
SAD PLANET**
BMI 2:50

PRINTED IN U.S.A.

Arranged by Charles R. Grean Produced by Charles R. Grean Recorded at Regent Sound Studios, New York City Engineer: Bob Liftin

For the finest reproduction of this Ultra High Fidelity Recording use the RIAA curve position. DOT RECORDS, INC., 1507 NORTH VINE STREET, HOLLYWOOD, CALIFORNIA 90028

STEREO PLAYABLE ON STEREO & MONAURAL PHONOGRAPHS

In My Own Way...I Love You

The Voice of

Anthony Quinn

with the Harold Spina Singers and Orchestra

Capitol RECORDS

26

ANTHONY QUINN ——————— In My Own Way...I Love You

On the back cover, Quinn tells us that this album was
conceived at a New Year's Eve party over a glass of
Merlot. What he fails to tell us is that this is the worst
album ever made.

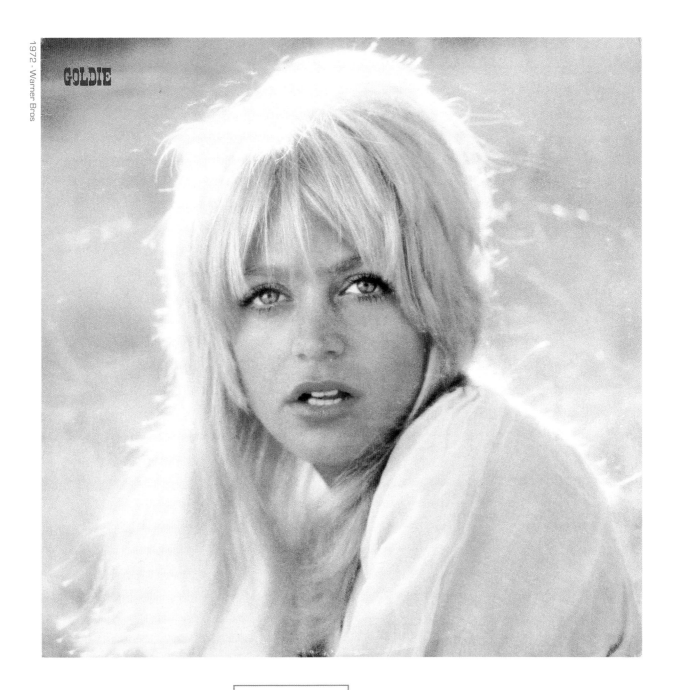

1972 - Warner Bros

GOLDIE

GOLDIE HAWN ——— Goldie

If Private Benjamin taught a nation how to laugh, this album taught a nation how to self-mutilate. Even though I had a crush on Goldie for the better part of 20 years, I'll never forgive her voice for killing eight kittens in my neighborhood.

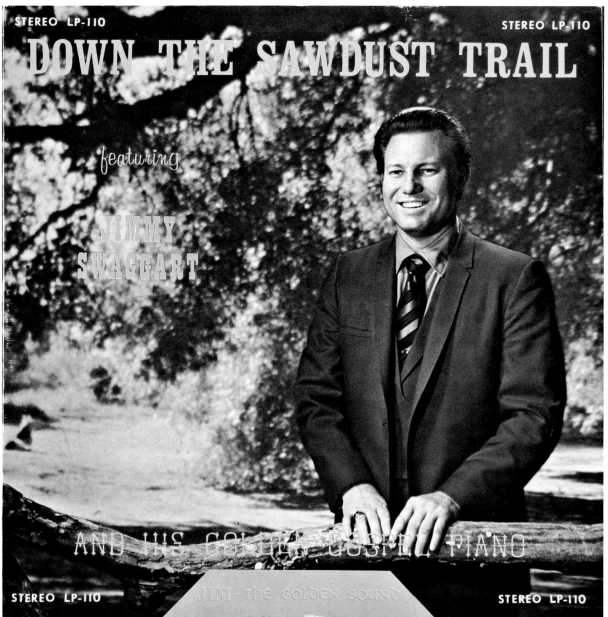

STEREO LP-110 STEREO LP-110

DOWN THE SAWDUST TRAIL

featuring

JIMMY SWAGGART

AND HIS GOLDEN GOSPEL PIANO

JIM - THE GOLDEN SOUND

STEREO LP-110 STEREO LP-110

JIMMY SWAGGART

Down The Sawdust Trail

There's not a graphic designer in the world that could duplicate the brilliance of this cover. Not a one. *Down the Sawdust Trail* broke the World Font Record in 1972.

INSTRUMENTAL

Camp Meeting Piano

featuring the

Piano Styles of Jimmy Swaggart

JIM LP-112

JIM LP-112

JIMMY SWAGGART

Camp Meeting Piano

The cousin of Jerry Lee Lewis isn't done yet. He did tons of these babies. Finally, some font discipline.

Did anyone else's summer camp have camp meetings about the importance of regular bowel movements? Anyone?

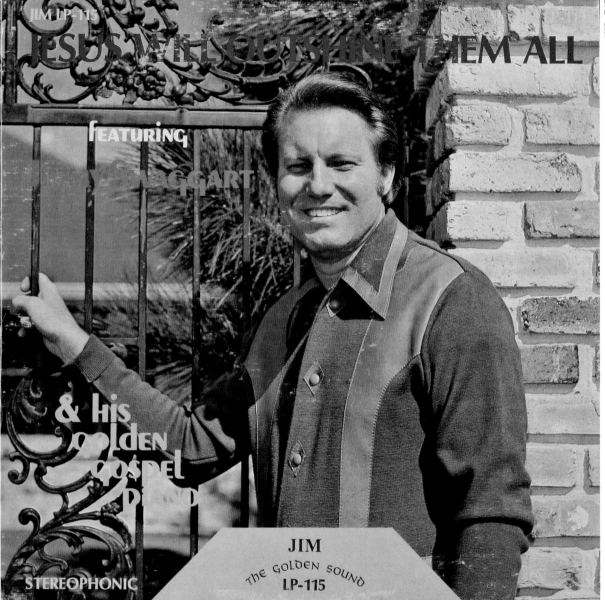

JIM LP-115

JESUS WILL OUTSHINE THEM ALL

FEATURING SWAGGART

& his golden gospel band

STEREOPHONIC

JIM
THE GOLDEN SOUND
LP-115

JIMMY SWAGGART — Jesus Will Outshine Them All

I've got to believe that there are better shirts for a Louisiana summer than ones involving leather collars.

carol Burnett ———— If I Could Write A Song

Time to tug the ear. The show is over.

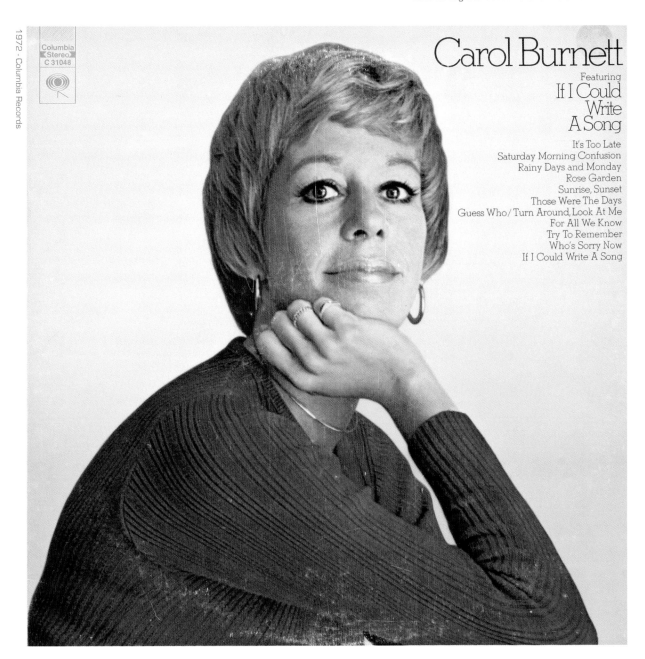

1972 - Columbia Records

Columbia
Stereo
C 31048

Carol Burnett

Featuring
If I Could
Write
A Song

It's Too Late
Saturday Morning Confusion
Rainy Days and Monday
Rose Garden
Sunrise, Sunset
Those Were The Days
Guess Who/ Turn Around, Look At Me
For All We Know
Try To Remember
Who's Sorry Now
If I Could Write A Song

31

Remembering You

Hi, my name is Carroll. I'll be your server tonight. Before I take your drink order, I'd like to tell you about our fantastic specials. First, we have a braised tilapia served atop a nice bed of mushroom risotto. That's $22.95. Next, we have a rosemary crusted rack of lamb served with garlic mashed potatoes and a golden beet salad. That's $28.95. Can I get some water for the table? Sparkling? Still? Tap?

32

1972 - A&M

CARROLL O'CONNOR
REMEMBERING YOU
I'LL NEVER BE THE SAME SWEET AND LOVELY ABOUT A QUARTER TO NINE SO RARE

SP 4340

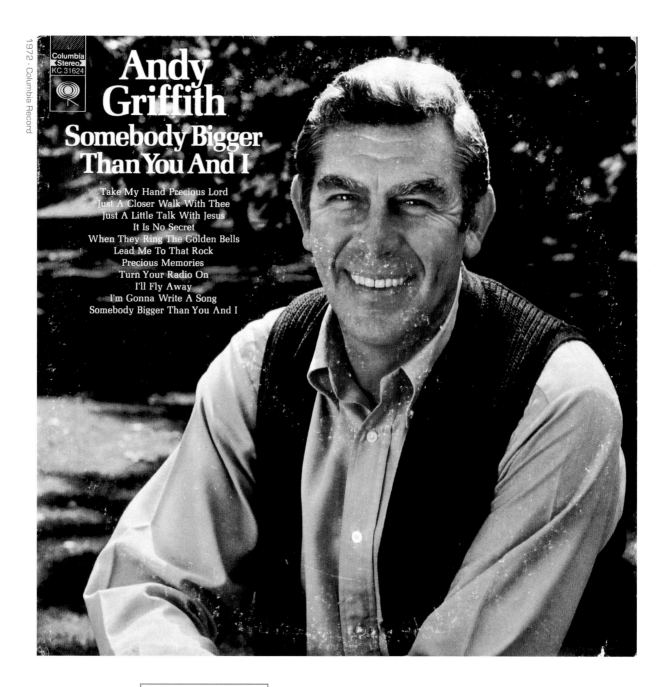

1972 - Columbia Record

Columbia
Stereo
KC 31624

Andy Griffith
Somebody Bigger Than You And I

Take My Hand Precious Lord
Just A Closer Walk With Thee
Just A Little Talk With Jesus
It Is No Secret
When They Ring The Golden Bells
Lead Me To That Rock
Precious Memories
Turn Your Radio On
I'll Fly Away
I'm Gonna Write A Song
Somebody Bigger Than You And I

ANDY GRIFFITH ———— Somebody Bigger Than You And I

Until someone tells me differently, I will assume that this
album is about Grimace.

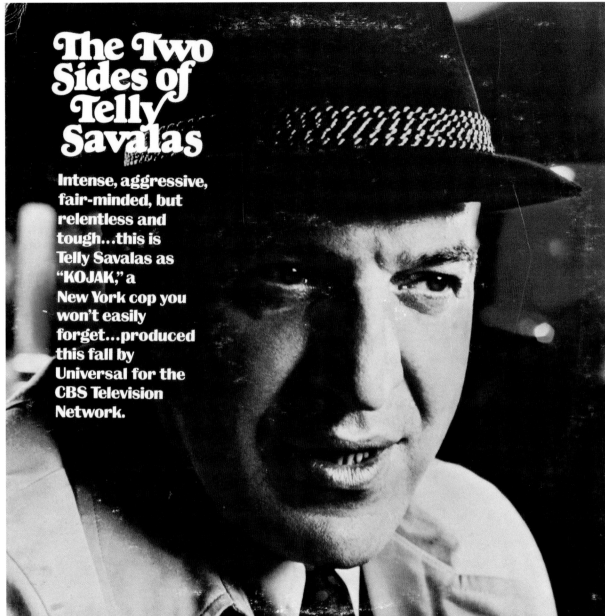

The Two Sides of Telly Savalas

Intense, aggressive, fair-minded, but relentless and tough...this is Telly Savalas as "KOJAK," a New York cop you won't easily forget...produced this fall by Universal for the CBS Television Network.

1972 - Jam

TELLY SAVALAS ———— The Two Sides of Telly Savalas

Side A: Horrible
Side B: Awful.

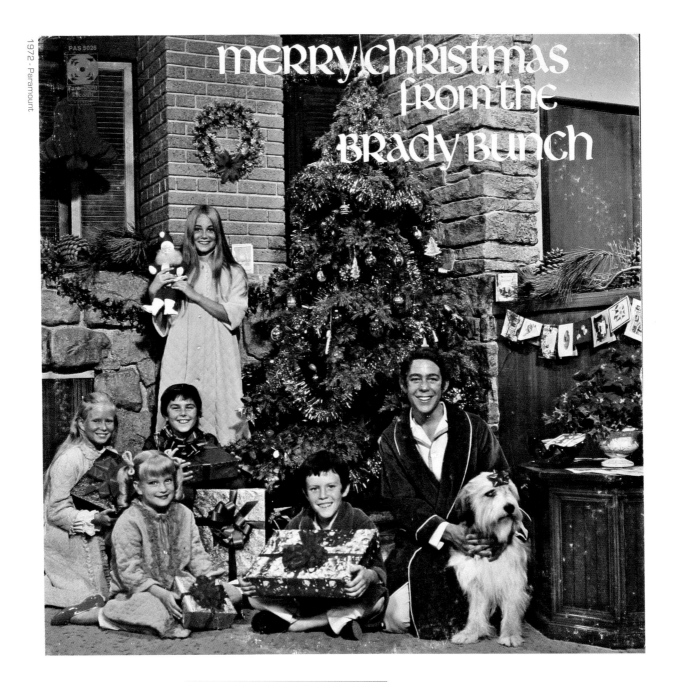

MERRY CHRISTMAS
FROM THE
BRADY BUNCH

PAS 5026

THE BRADY BUNCH KIDS ——————— Merry Christmas From The Brady Bunch

Unfortunately, to safely remove the bow
from Tiger's head, he had to be euthanized
on December 26th.

The (KIDS) from the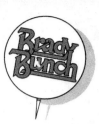

L- -ve DO-RE-(__)

It's a - -d-

 -p on -ing the

 N-ever s- -s.

 -ing the f- -d

THE BRADY BUNCH KIDS ——— **The Kids From The Brady Bunch**

If it weren't for Cousin Oliver, these guys would be on album number 30. Instead, we see a spandexed Peter Brady selling exercise equipment on late night infomercials. Such is the way of bespectacled cousins.

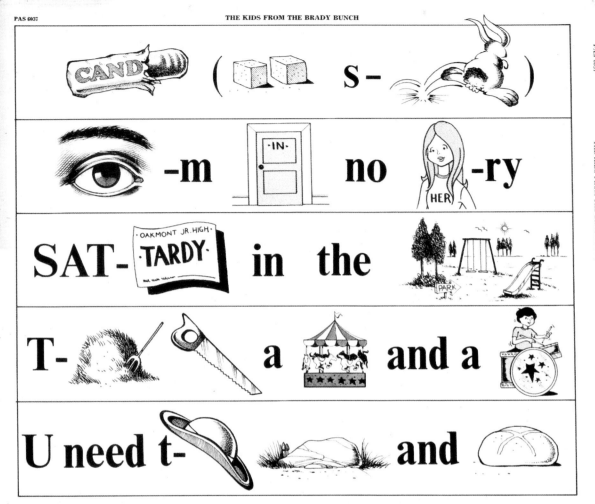

SIDE 1 **LOVE ME DO** (J. Lennon/P. McCartney) Beechwood Music (BMI) • **IT'S A SUNSHINE DAY** (Stephen R. McCarthy) Language of Sound, Inc./Famous Music (ASCAP)

KEEP ON (J. Mills/T. Jenkins) Famous Music (ASCAP) • **BEN** (D. Black/W. Scharf) Jobete (ASCAP) • **PLAYIN' THE FIELD** (B. Neary/J. DiMuro) Famous Music (ASCAP)

SIDE 2 **CANDY (Sugar Shoppe)** (G. Rogalski/J. E. Lindvald) Ensign Music Corp. (BMI)/Green Apple Music Co. (BMI) • **IN NO HURRY** (T. Dancy/C. Fairchild) Famous Music (ASCAP)

SATURDAY IN THE PARK (R. Lamm) Big Elk Music (ASCAP) • **MERRY-GO-ROUND** (B. Neary/J. DiMuro) Famous Music (ASCAP) • **YOU NEED THAT ROCK 'N ROLL** (D. Hull)

Language of Sound (ASCAP)/Famous Music (ASCAP) • **DRUMMER MAN** (J. Mills/D. Janssen) Language of Sound/Famous (ASCAP) Green Apple Music/Ensign Music (BMI)

Produced by Jackie Mills for Wednesdays Child Productions • Arranged by Al Capps, Engineer: Lenny Roberts • Recorded at Larrabee Sound Studios, Hollywood, California

Art Direction: Bill Levy • Illus.: Joe Petagno • Package Concept and Design: Pacific Eye & Ear

Save the Forests. This album is printed on recycled paper. ℗ 1972 Paramount Records. Distributed by Famous Music Corp. A G+W Company.

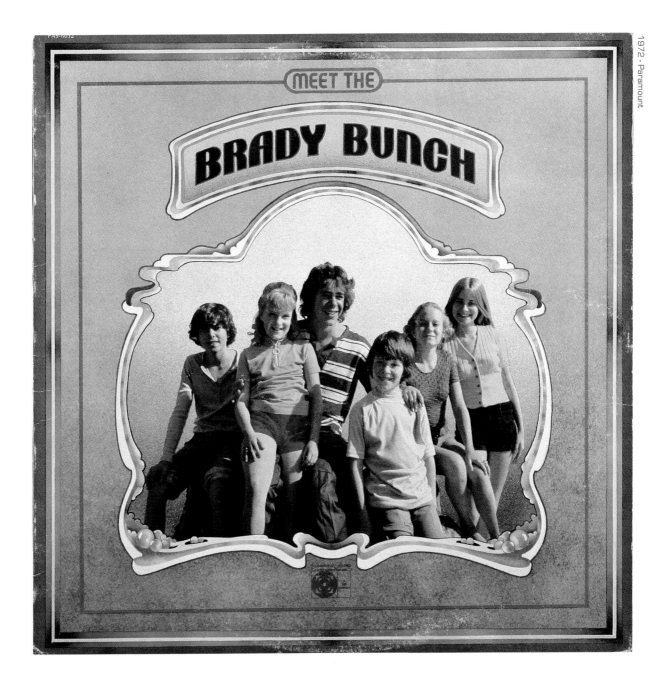

1972 - Paramount

THE BRADY BUNCH KIDS —— Meet The Brady Bunch

Marcia, Marcia, Marcia in shorts, shorts, shorts.

PAS-6032

MEET THE BRADY BUNCH

Side One	Side Two
We'll Always Be Friends * 2:37	Me And You And A Dog Named Boo ** 3:00
Day After Day ** 3:09	I Just Want To Be Your Friend * 2:33
Baby, I'm-A Want You * 2:42	Love My Life Away * 2:38
I Believe In You * 1:56	Come Run With Me ** 2:43
American Pie * 3:39	Ain't It Crazy * 2:07
Time To Change ** 2:08	We Can Make The World A Whole Lot Brighter * 2:25

39

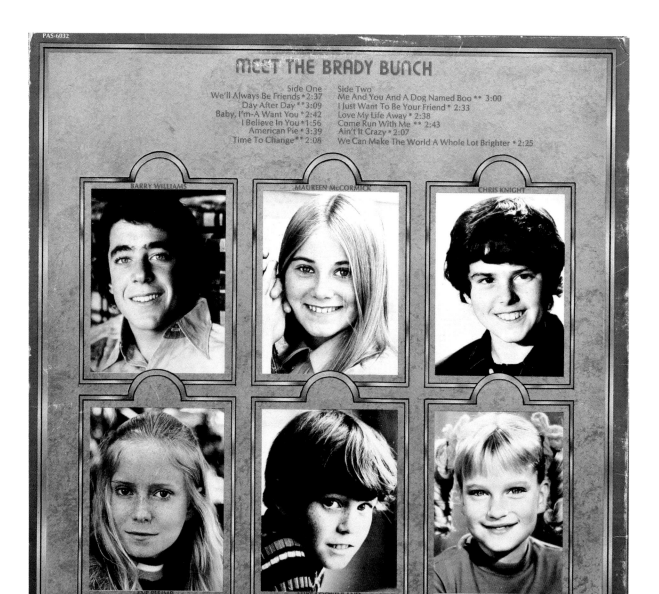

BARRY WILLIAMS MAUREEN McCORMICK CHRIS KNIGHT

EVE PLUMB MIKE LOOKINLAND SUSAN OLSEN

Produced by Jackie Mills for Wednesday's Child Productions * Arranged by Al Capps * Cover photos by Jim Jenkins

Paramount Records. Manufactured By Famous Music Corporation, A G+W Company *BMI **ASCAP

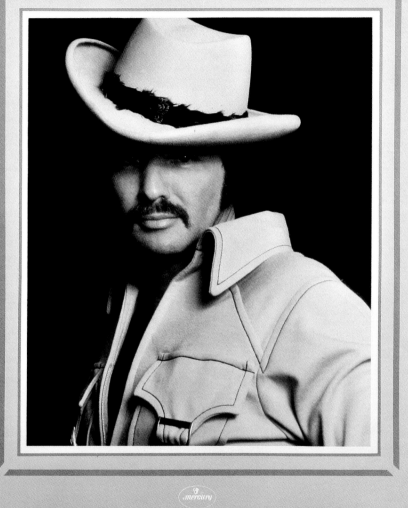

BURT REYNOLDS

ASK ME WHAT I AM

STEREO SRM-1-693

BURT REYNOLDS

Ask Me What I Am

Let me begin by saying Burton Leon Reynolds is the biggest bad ass in the history of film. I would take a bullet for Gator McKlusky. But no matter how much courage it took to save Ned Beatty's virginal anus in *Deliverance*, it didn't take half the courage that making this piece of shit took. What the hell is Burt wearing here? Did he just get invited to Jim J. Bullock's house for a game of Cowboy and Indian? And what's with the title *Ask Me What I Am*? I'll tell you what you are, Burt: a douche.

CHILDHOOD 1949 • SLOW JOHN FAIRBURN • THE FIRST ONE THAT I LAY WITH • TILL I GET IT RIGHT • SHE'S TAKEN A GENTLE LOVER
YOU CAN'T ALWAYS SING A HAPPY SONG • ASK ME WHAT I AM • A ROOM FOR A BOY NEVER USED • I DIDN'T SHAKE THE WORLD TODAY
THERE'S A SLIGHT MISUNDERSTANDING BETWEEN GOD AND MAN • I LIKE HAVING YOU AROUND

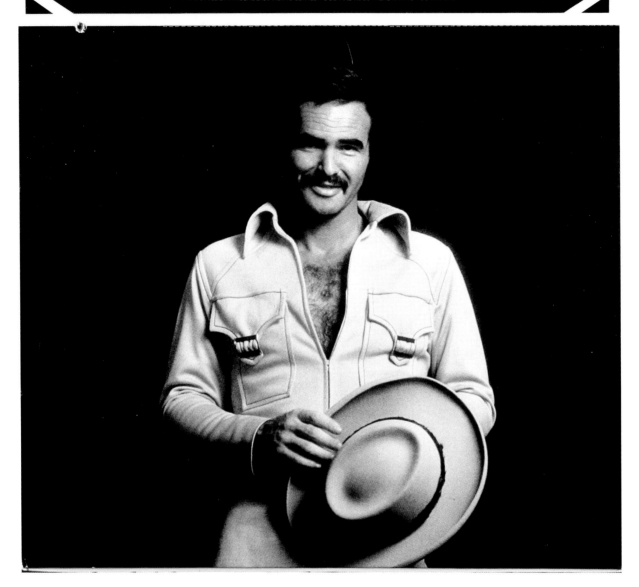

41

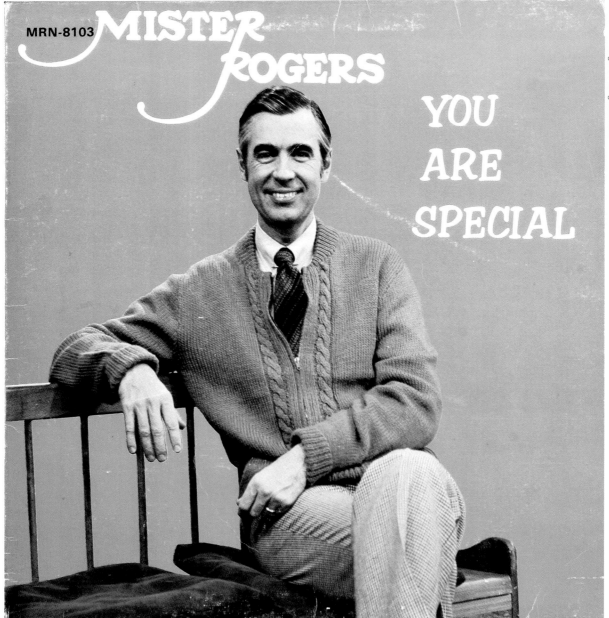

MRN-8103

MISTER ROGERS

YOU ARE SPECIAL

1973 - Mr Rogers's Neighborhood

MISTER ROGERS — You Are Special

As a little kid, I truly wanted Fred Rogers to be my neighbor. Now, I'm not so sure. A little too much of John Mark Carr thing going on for me. Cardigan Fever. Catch it!

1973 - Mercury

JOHN DAVIDSON

...well, here I am

Featuring
What She Left Of Me
As Lonely As You
Good Time Charlie's Got The Blues
Baby Don't Get Hooked On Me
Soul Song

©PHONOGRAM INC., 1973 - PRINTED IN U.S.A.

STEREO SRM 1-658

43

JOHN DAVIDSON ———————— Well, Here I Am

That's incredible.

1973 - London

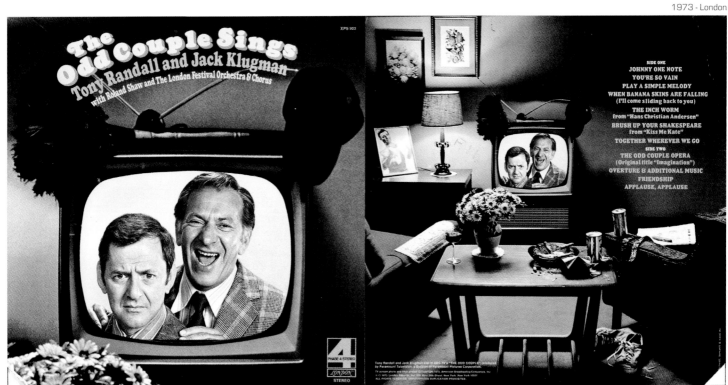

TONY RANDALL AND JACK KLUGMAN ——— The Odd Couple Sings

Quincy M.D. would solve this musical
sodomy in the first two minutes.

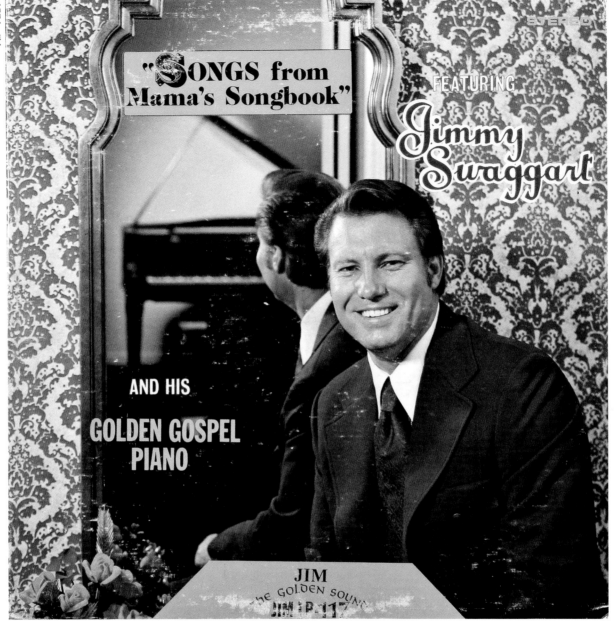

"SONGS from Mama's Songbook"

FEATURING

Jimmy Swaggart

AND HIS

GOLDEN GOSPEL PIANO

JIM
THE GOLDEN SOUND
JIM LP-117

1974 - JIM

STEREO

45

JIMMY SWAGGART ——————— Songs From Mama's Songbook

Again with the fonts. Which song from Mama's songbook told him to buy a whore in 1988?

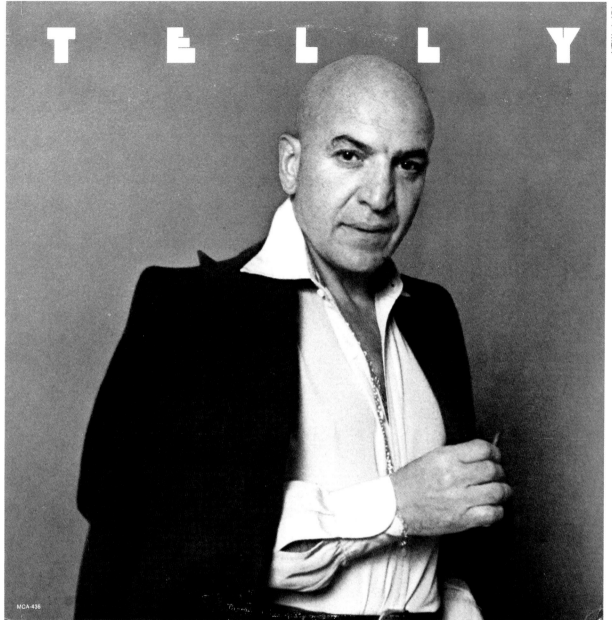

1974 - MCA

MCA-436

TELLY SAVALAS ——— Telly

Who loves ya baby? No one.

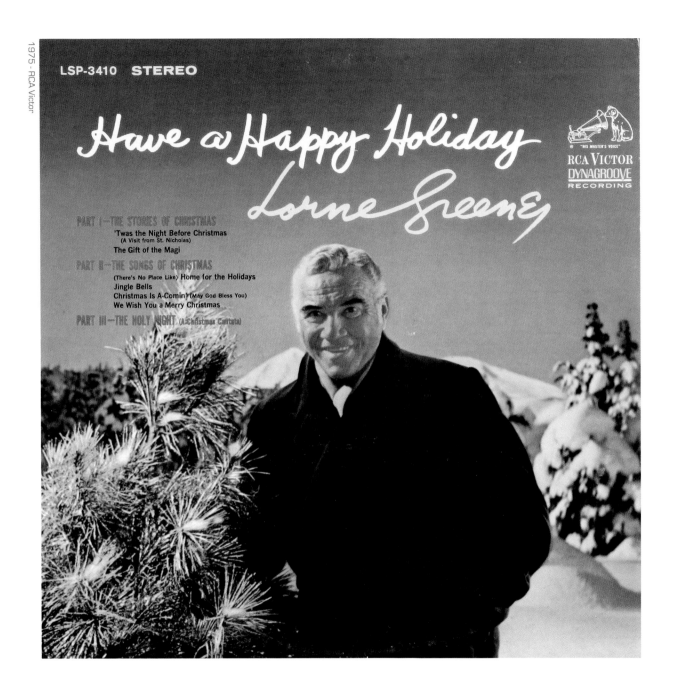

LSP-3410 STEREO

Have a Happy Holiday

Lorne Greene

RCA VICTOR
DYNAGROOVE
RECORDING

PART I—THE STORIES OF CHRISTMAS
 'Twas the Night Before Christmas
 (A Visit from St. Nicholas)
 The Gift of the Magi
PART II—THE SONGS OF CHRISTMAS
 (There's No Place Like) Home for the Holidays
 Jingle Bells
 Christmas Is A-Comin' (May God Bless You)
 We Wish You a Merry Christmas
PART III—THE HOLY NIGHT (A Christmas Cantata)

LORNE GREENE ———— Have A Happy Holiday

Unfortunately, Hoss and Little Joe had to sell Hop Sing
to the railroad company in order to finance this album.

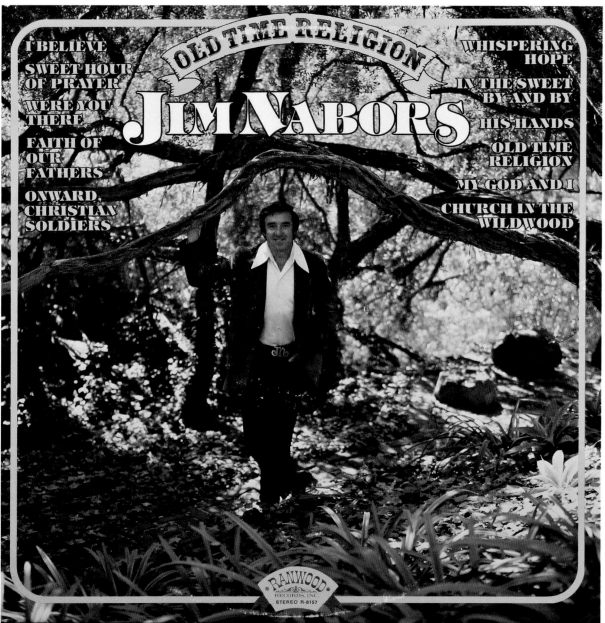

48

JIM NABORS ──── Old Time Religion

Well, gollllllllly. Jim has a belt buckle with his initials on it.

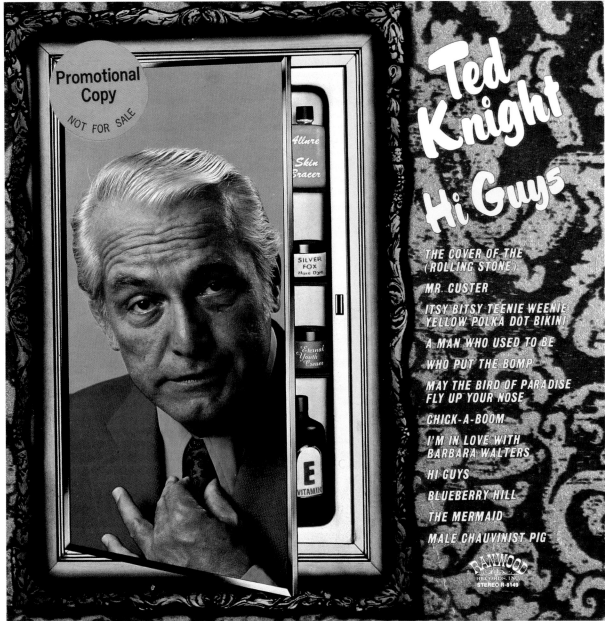

49

TED KNIGHT ——— Hi Guys

With the exception of his "Itsy Bitsy Teenie Weenie Yellow Polka Dot Bikini" cover, this man has not made one poor career choice. Not a one. Fresca should name a building after him.

50

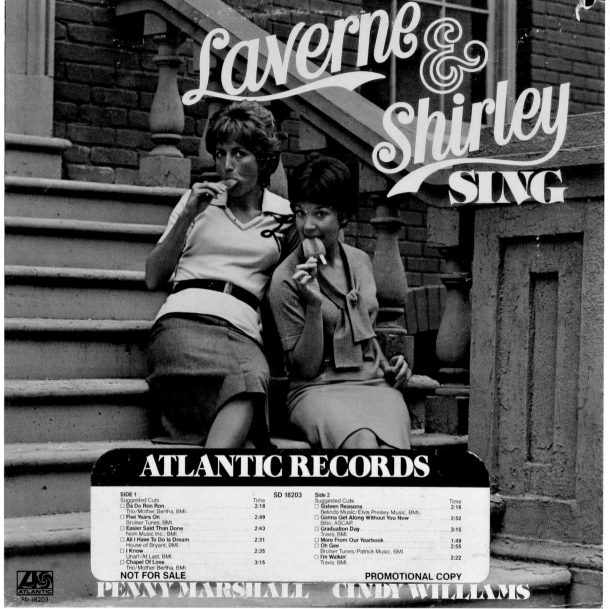

Laverne & Shirley Sing

It's as if someone took a Big Ragu right in the middle of the room.

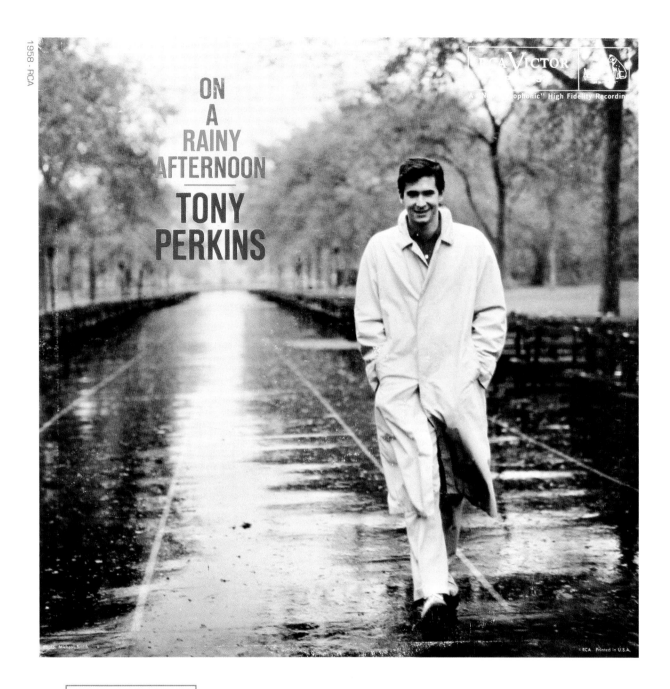

ON
A
RAINY
AFTERNOON

TONY
PERKINS

RCA VICTOR

A "New Orthophonic" High Fidelity Recording

Photo: Michael Smith

RCA Printed in U.S.A.

51

TONY PERKINS ——————— On a Rainy Afternoon

Psycho.

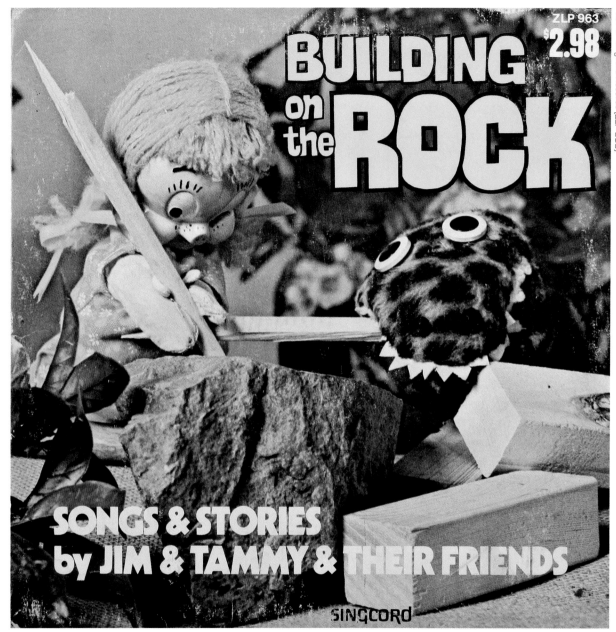

ZLP 963

$2.98

1975 - Singcord Records (ZLP 963)

BUILDING on the ROCK

SONGS & STORIES by JIM & TAMMY & THEIR FRIENDS

SINGCORD

JIM & TAMMY FAYE BAKKER

Building on the Rock

If you had to pick one song. And just one. A bettin' man would have to guess that Jim Bakker destroyed Jessica Hahn's innocence to "The Devil is a Sly Ole Fox." That song is unadulterated humping music. And not dry humping either. Sweaty preacher to sweaty secretary humping. The kind of humping that would cause Tammy Faye to cry ink for years.

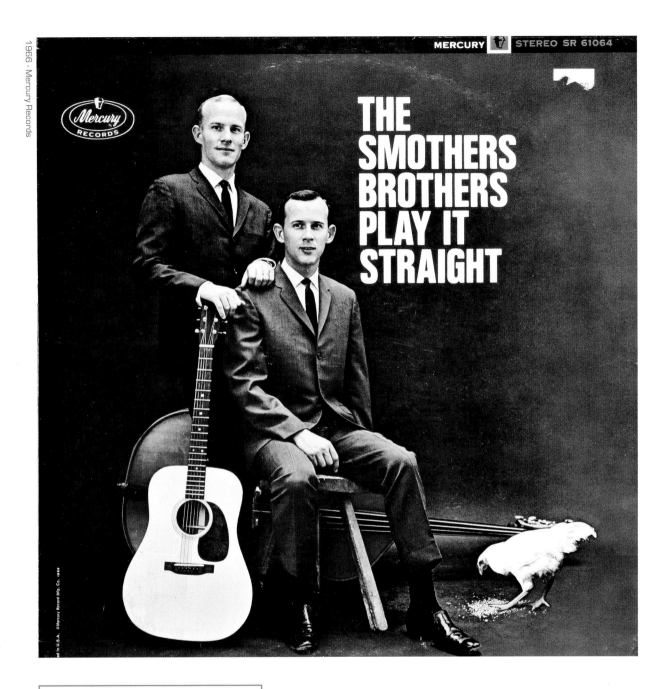

MERCURY STEREO SR 61064

THE
SMOTHERS
BROTHERS
PLAY IT
STRAIGHT

THE SMOTHERS BROTHERS ———— The Smothers Brothers Play It Straight

Good call.

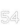

1976 - Midland Int

BKL1-1563

JOHN
TRAVOLTA

MIDLAND
INTERNATIONAL
BKL1-1563
STEREO
RE

JOHN TRAVOLTA

John Travolta

I didn't know JCPenney turtlenecks
came in Dreamboat Blue?

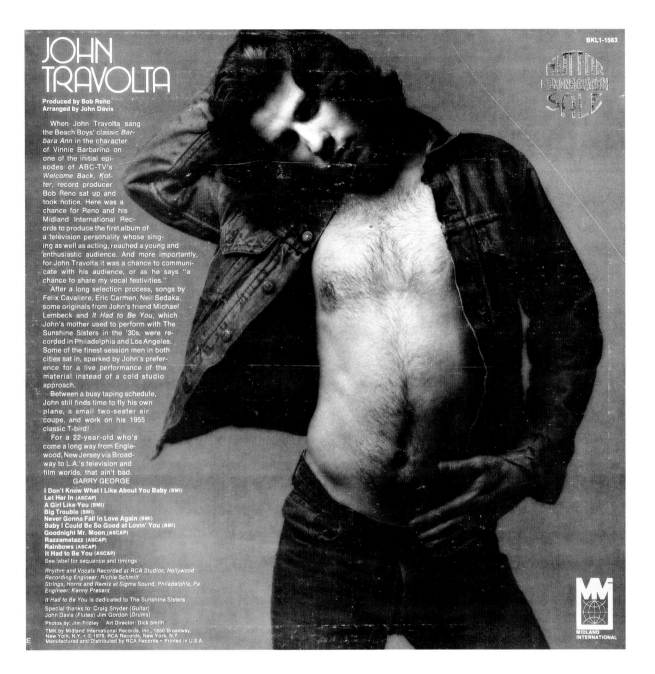

BKL1-1563

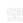

JOHN TRAVOLTA

Produced by Bob Reno
Arranged by John Davis

When John Travolta sang the Beach Boys' classic *Barbara Ann* in the character of Vinnie Barbarino on one of the initial episodes of ABC-TV's *Welcome Back, Kotter*, record producer Bob Reno sat up and took notice. Here was a chance for Reno and his Midland International Records to produce the first album of a television personality whose singing as well as acting, reached a young and enthusiastic audience. And more importantly, for John Travolta it was a chance to communicate with his audience, or as he says "a chance to share my vocal festivities."

After a long selection process, songs by Felix Cavaliere, Eric Carmen, Neil Sedaka, some originals from John's friend Michael Lembeck and *It Had to Be You*, which John's mother used to perform with The Sunshine Sisters in the '30s, were recorded in Philadelphia and Los Angeles. Some of the finest session men in both cities sat in, sparked by John's preference for a live performance of the material instead of a cold studio approach.

Between a busy taping schedule, John still finds time to fly his own plane, a small two-seater air coupe, and work on his 1955 classic T-bird!

For a 22-year-old who's come a long way from Englewood, New Jersey via Broadway to L.A.'s television and film worlds, that ain't bad.

GARRY GEORGE

I Don't Know What I Like About You Baby (BMI)
Let Her In (ASCAP)
A Girl Like You (BMI)
Big Trouble (BMI)
Never Gonna Fall in Love Again (BMI)
Baby I Could Be So Good at Lovin' You (BMI)
Goodnight Mr. Moon (ASCAP)
Razzamatazz (ASCAP)
Rainbows (ASCAP)
It Had to Be You (ASCAP)
See label for sequence and timings

Rhythm and Vocals Recorded at RCA Studios, Hollywood
Recording Engineer: Richie Schmitt
Strings, Horns and Remix at Sigma Sound, Philadelphia, Pa.
Engineer: Kenny Present

It Had to Be You is dedicated to The Sunshine Sisters

Special thanks to: Craig Snyder (*Guitar*)
John Davis (*Flutes*) Jim Gordon (*Drums*)
Photos by: Jim Fridley Art Director: Dick Smith

MIDLAND
INTERNATIONAL

1976 - Island

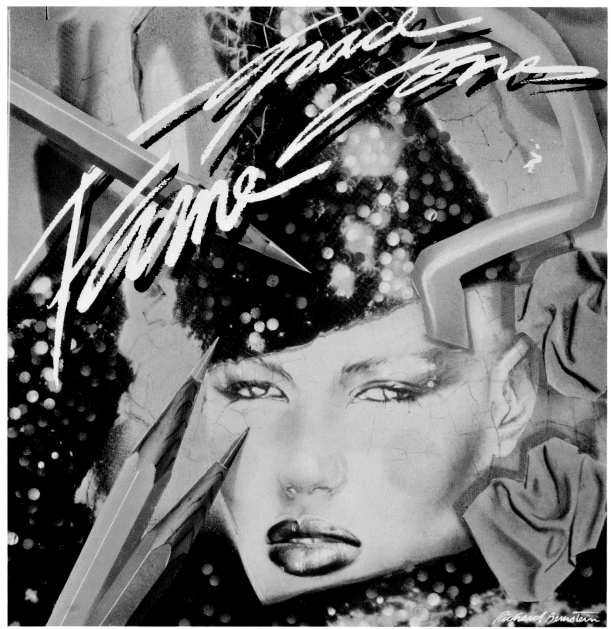

grace jones ———— **Fame**

- Famous for disco music.
- Famous for being Dolph Lundgren's ex-girlfriend.
- Famous for giving birth to a bottle of Estrange perfume in the movie *Boomerang*.

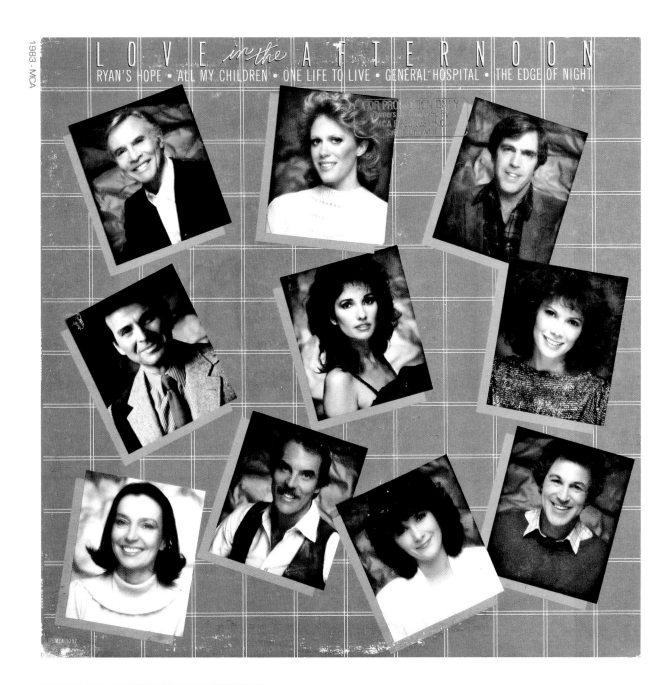

LOVE *in the* AFTERNOON

RYAN'S HOPE • ALL MY CHILDREN • ONE LIFE TO LIVE • GENERAL HOSPITAL • THE EDGE OF NIGHT

57

ABC SOAP OPERA STARS ——— Love in the Afternoon

Music by Satan. Art direction by Tron.

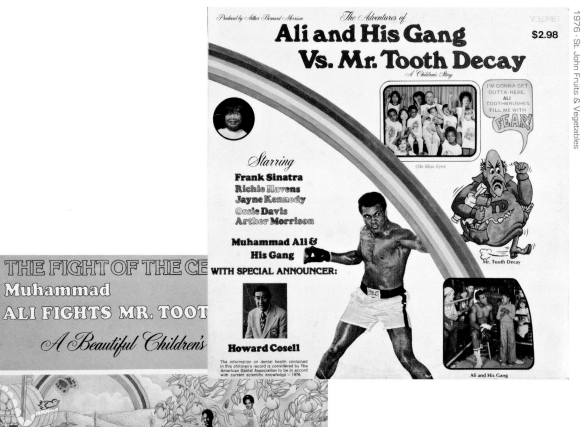

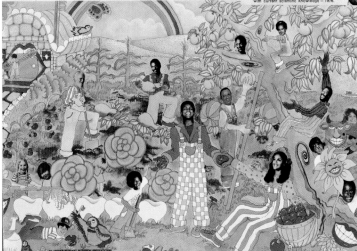

MUHAMMAD ALI ———————— The Adventure of Ali and His Gang Vs. Mr. Tooth Decay. A Children's Story.

Watch out, gum disease! Muhammad Ali has had enough. What the fuck is going on here? And how much Goldenschlager did it take to convince Sinatra to pick peaches on the back cover? For you legal sticklers out there, you'll be happy to note that the information found on this vinyl is "in accord with scientific knowledge as of 1976." Why does this also sound like an admission of guilt?

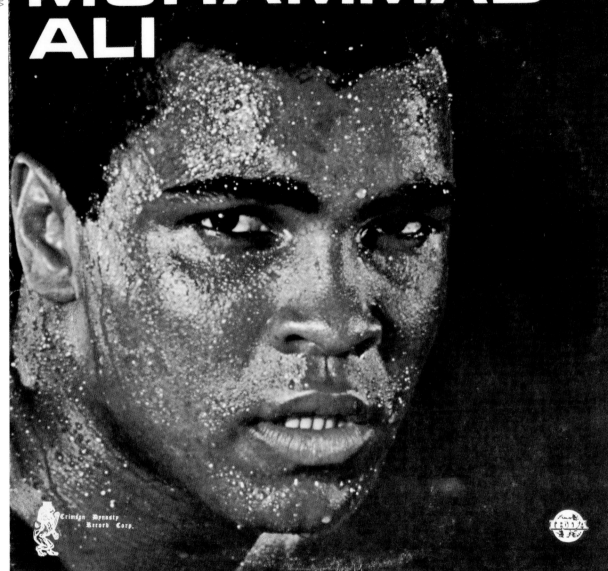

MUHAMMAD ALI ——————— I'm The Greatest

Hmmm. Interesting choice. A straight-up solo album. In case you were confused by the giant headshot or 96-point font on the cover, the album's copy lets you know that these are "songs performed by, written by or about Muhammad Ali!" If I had to put my favorite egocentric songs in order, I'd have to say: "Ali's Elusive Dream," "Ali's Dream," "Muhammed Ali," "Don't Mess With Ali" and "Ali's Theme." I pity those of you who ask what's the difference between "Ali's Elusive Dream" and "Ali's Dream." You are lost.

1976 - 20th Century Records

T-512

JOHN DAVIDSON ——————— **Every Time I Sing A Love Song**

I beg of you, please go to johndavidson.com
and make sure your sound is on.

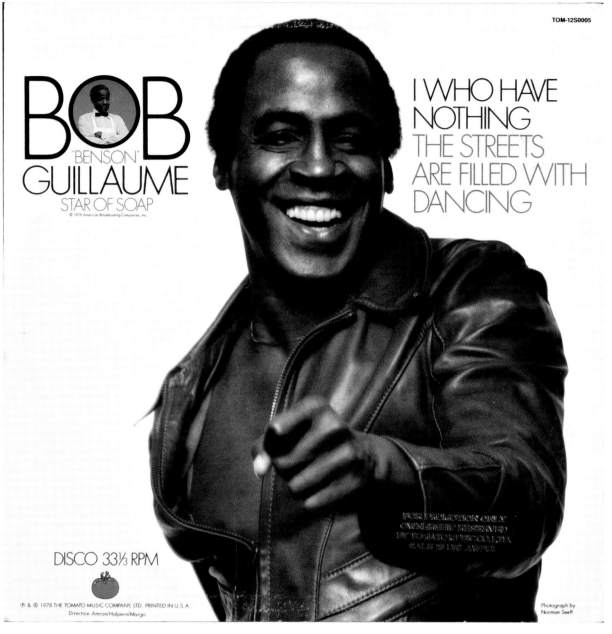

TOM-12S0005

BOB "BENSON" GUILLAUME
STAR OF SOAP
© 1978 American Broadcasting Companies, Inc.

I WHO HAVE NOTHING
THE STREETS ARE FILLED WITH DANCING

DISCO 33⅓ RPM

℗ & © 1978 THE TOMATO MUSIC COMPANY, LTD. PRINTED IN U.S.A.
Direction Amron/Halpern/Margo

Photograph by Norman Seeff

FOR PROMOTION ONLY
OWNERSHIP RESERVED
BY TOMATO MUSIC CO., LTD.
SALE IS UNLAWFUL

BOB "BENSON" GUILLAME ——— I Who Have Nothing

The "Unzip and Point." A rare but often effective way to let America know that you are much, much more than just a governor's housekeeper.

1977 - Midland Int.

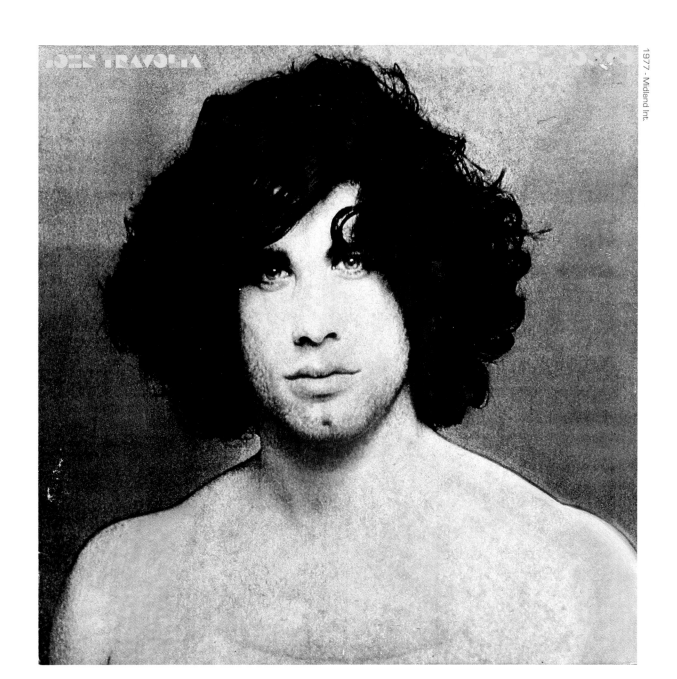

JOHN TRAVOLTA ————— Can't Let You Go

This can't help the gay rumors.

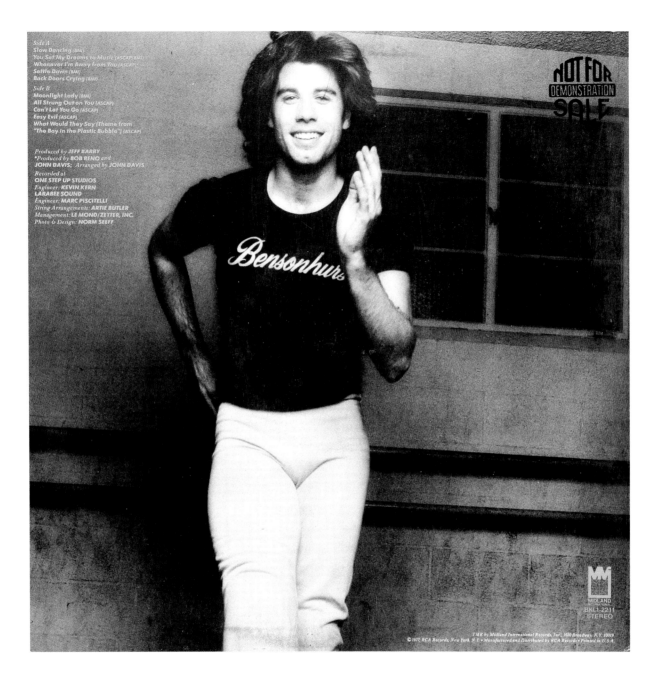

Side A
Slow Dancing (BMI)
You Set My Dreams to Music (ASCAP/BMI)
Whenever I'm Away from You (ASCAP)
Settle Down (BMI)
Back Doors Crying (BMI)

Side B
Moonlight Lady (BMI)
All Strung Out on You (ASCAP)
Can't Let You Go (ASCAP)
Easy Evil (ASCAP)
What Would They Say (Theme from
"The Boy in the Plastic Bubble") (ASCAP)

Produced by **JEFF BARRY**
Produced by* **BOB RENO *and*
JOHN DAVIS; *Arranged by* **JOHN DAVIS**
Recorded at
ONE STEP UP STUDIOS
Engineer: **KEVIN KERN**
LARABEE SOUND
Engineer: **MARC PISCITELLI**
String Arrangements: **ARTIE BUTLER**
Management: **LE MOND/ZETTER, INC**
Photo & Design: **NORM SEEFF**

NOT FOR
DEMONSTRATION
SALE

MIDLAND
INTERNATIONAL
BKL1-2211
STEREO

TMR by Midland International Records, Inc., 1650 Broadway, N.Y. 10019
© 1977, RCA Records, New York, N.Y. • Manufactured and Distributed by RCA Records • Printed in U.S.A.

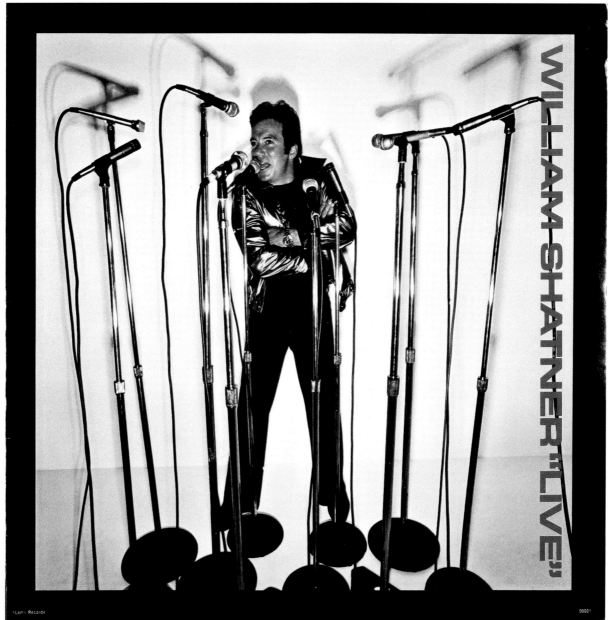

WILLIAM SHATNER "LIVE"

00001

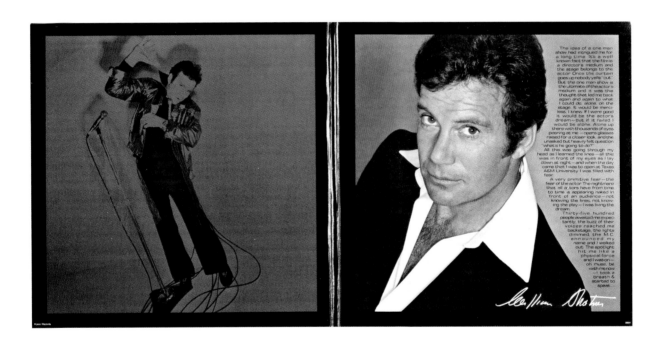

WILLIAM SHATNER ——————— Live

Shatner won an Emmy for *Boston Legal*? Really?

How many 400-pound cat owners does it take to make that happen?

1977 - Capricorn

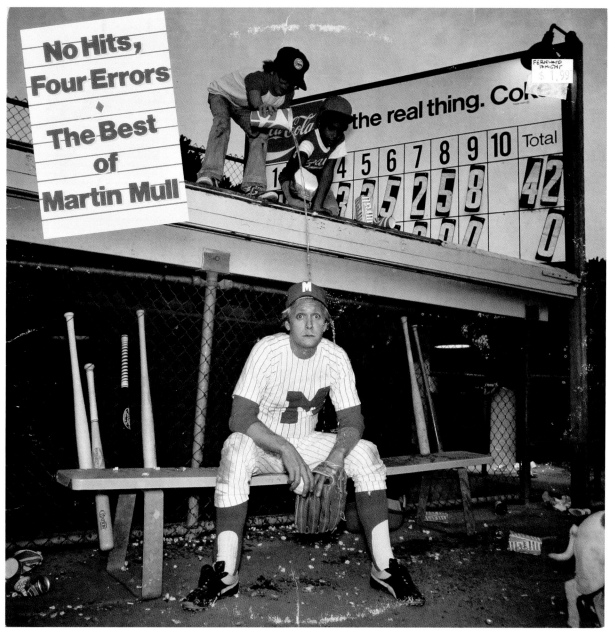

MARTIN MULL — No Hits, Four Errors. The Best Of Martin Mull

In all fairness to Martin, I've never listened to this album and I'm not even sure he would be considered a celebrity.

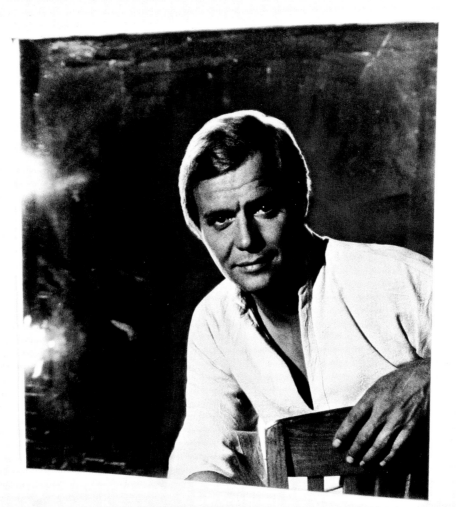

PLAYING TO AN AUDIENCE OF ONE

David Soul

1977 - Private Stock

67

DAVID SOUL ——————— Playing To An Audience Of One

Perhaps the most appropriate title in my
entire collection. I imagine the "one" that
Hutch is "playing to" is his partner, Starsky.
I also imagine that Starsky is very drunk
and has no place else to go.

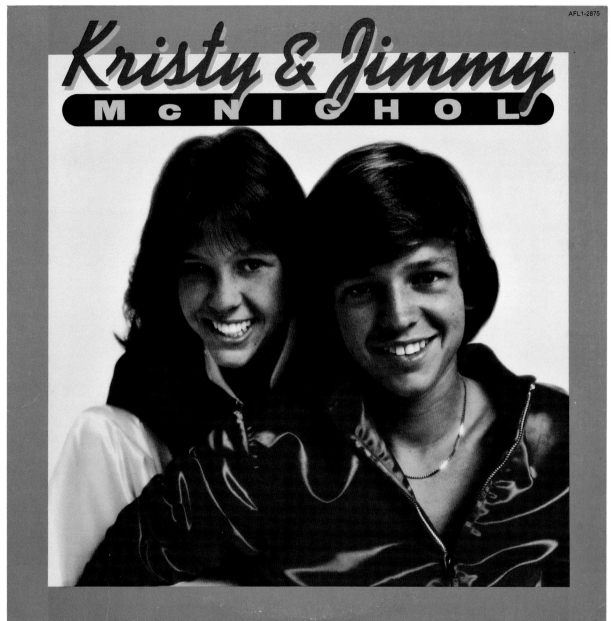

68

KRISTY & JIMMY MCNICHOL ——————— Kristy & Jimmy McNichol

These two were famous for something back in the day. If you can remember what for, please post something on Wikipedia.

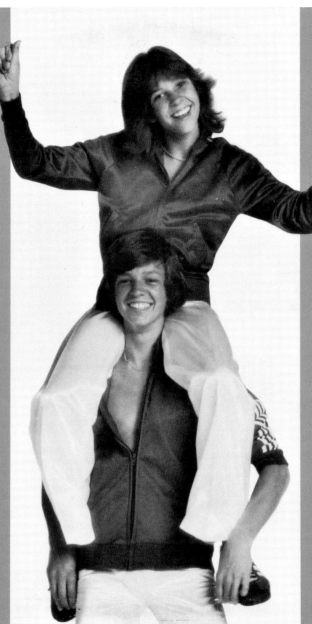

SIDE A

HE'S A DANCER
PAGE BY PAGE
GIRL YOU REALLY GOT ME GOIN'
MY BOYFRIEND'S BACK
SLOW DANCE

SIDE B

HE'S SO FINE
BOX ON WHEELS
GO FOR IT
ROCK & ROLL IS HERE TO STAY
HOT TUNES

All songs written by Phil & Mitch Margo and published by Thankyouthankyouthankyou Music, Inc. (ASCAP) except for HE'S SO FINE, Ronnie Mack, Bright-Tunes Music, Inc. (BMI); ROCK & ROLL IS HERE TO STAY, D. White, Singular Publishing Co. (BMI); MY BOYFRIEND'S BACK, B. Feldman-G. Goldstein-R. Gottehrer, Blackwood Music Inc. (BMI).

PRODUCED BY PHIL AND MITCH MARGO FOR AMRON/HALPERN/MARGO PRODUCTIONS, INC.
Executive Producers: Alan Amron and Larry Halpern
Arranged by Mitch Margo

MUSICIANS:

GUITARS	Marlo Henderson
	Ben Bridges
DRUMS	James Gadson
	Raymond Pounds
BASS	Nate Watts
KEYBOARDS	Don Freeman
	Mitch Margo
PERCUSSION	Paulinho Da Costa*
	Joe Blocker
	Phil Margo
	Mitch Margo
SYNTHESIZER	Mitch Margo

BACKGROUND VOCALS:

The Chiffons —
HE'S SO FINE
Susan Morse
Geri (Dodie) Stevens
Maxine Green
Mitch Margo
Phil Margo

Direction: Amron/Halpern/Margo Productions, Inc.
*Paulinho Da Costa exclusive Pablo recording artist

SPECIAL THANKYOUTHANKYOUTHANKYOU TO:

Carolyn McNichol
Alice Pike
Max Morrow
Julie Gabriel
Sherry Margo
Burt Reynolds
Abbie Margo
Tony Masucci
Tom Wilson
Paula Jeffries
Larry Sikora
Jim Pike
Mike Douglas
Gloria Amron
Lee Halpern
Warren Schatz

RECORDED AT:
Crystal Sound Studios
ENGINEERS: David Henson, John Fischbach
ASSISTANTS: Laura Livingston, James Hill

Filmways/Heider Recording Studios
ENGINEERS: Mickey Crofford, Grover Helsley, David Gertz
ASSISTANTS: Sean Fullan, Ira Leslie.

REMIX ENGINEER: Jerrold Solomon

ALBUM DESIGN: Tim Bryant & George Corsillo/ GRIBBITT!
PHOTOGRAPHY: Ron Slenzak
COSTUME COORDINATOR: Eileen Amron

THANKYOUTHANKYOUTHANKYOU

RCA
AFL1-2875 STEREO

CHERYL LADD

Cheryl Ladd

Grrrrr. The Japanese and I see eye-to-eye on Cheryl. Of Cheryl's six career albums, four of them were Japan-only releases. The hottest song on this self-titled album is "Skinnydippin'" and it contains these subtly beautiful lyrics: *Who cares what people sayyyy. The water is nice and coooool. We'll love the night away. Doing things they don't teach in schooool. Waaa-ohhh, waaa-ohhh goin' skinnydippin'...soul-kissin'...* If you want to listen to the magic for yourself, be the second lifetime visitor to Cheryl's music website: cherylladd.com/music

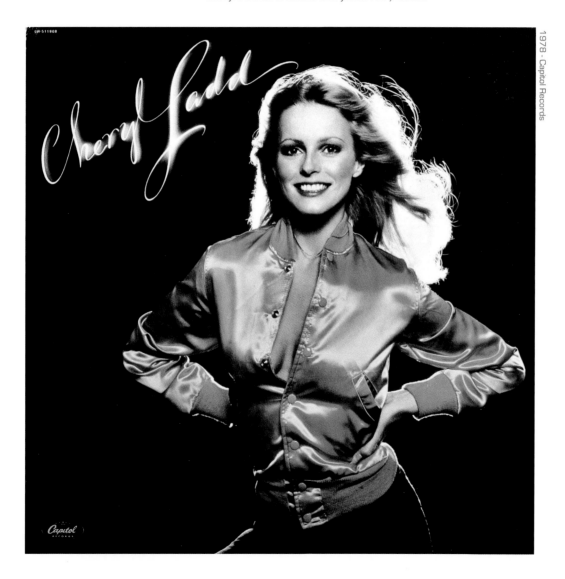

1978 - Capitol Records

THE *ETHEL MERMAN DISCO ALBUM*

1979 - E&M Records

ETHEL MERMAN — The Ethel Merman Disco Album

Unbelievable. This album is a true testament to just how much cocaine was streaming into the U.S. in the late 70s. Unfortunately, this album leaves me with more questions than answers. Like, who's holding the hat? Is that Ethel's dance partner? He's wearing a wedding band – is it her boy-toy husband? Regardless of who this guy is, what do you think this guy was like? I bet he was some eager model who showed up late and proceeded to tell stories about himself around the craft service's table. Then, I bet he drove home in his Firebird, got coked up and masturbated to Bachman Turner Overdrive. I am haunted by this hand.

THE NEW YORK ISLANDERS — A Christmas Album

This is what Amy Fisher was listening to right before she put a cap in Mary Jo Buttafuco. And when I say Amy Fisher, I mean the Amy Fisher played by Alyssa Milano. Not the Amy Fisher played by Drew Barrymore.

Tammy Faye Bakker

THE LORD'S ON MY SIDE
PSALM 124:2

Featuring The Hit Single **If It Had Not Been**

TAMMY FAYE BAKKER ——— The Lord's On My Side (Psalm 124:2)

If I had a time machine that granted me access to the early 80s, I'd do two things. Punch John Cougar Mellencamp in the throat. And invent spray-on mascara.

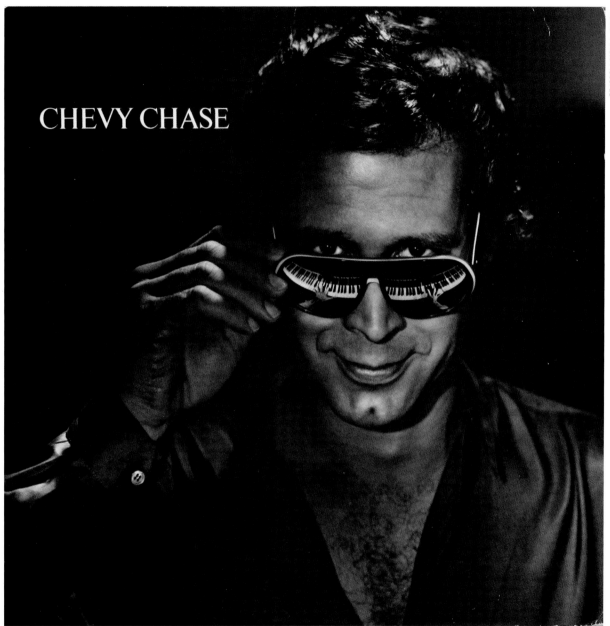

CHEVY CHASE

CHEVY CHASE ——— Chevy Chase

Ladies and gentlemen, I present to
you *Cops and Robbersons* set to
music. "I Shot The Sheriff"? Are you
fucking kidding me? I miss Chevy's
coke habit.

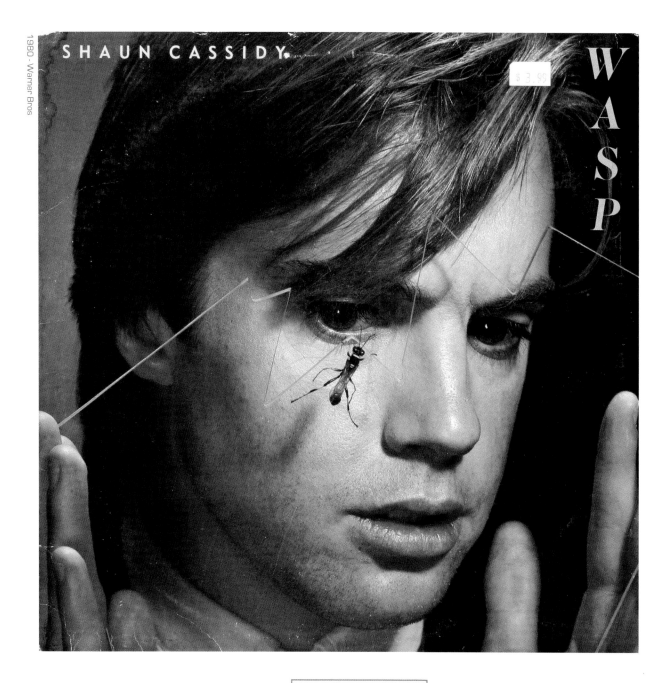

SHAUN CASSIDY

$ 3.95

WASP

75

SHAUN CASSIDY ——————— Shaun Cassidy

Wasp vs. wasp.

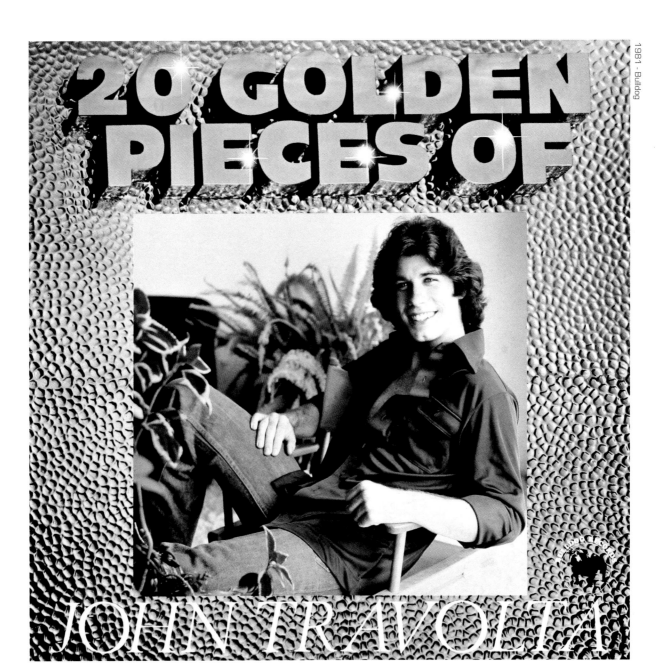

76

20 GOLDEN PIECES OF

JOHN TRAVOLTA

JOHN TRAVOLTA ——————— 20 Golden Pieces of John Travolta

Introducing the hymns by which all Scientologists live their lives. Suri Cruise was conceived to this album.

THE STARS OF GENTLE BEN ─────── The Bear Facts

Being best friends with a bear must have been a common thing back in the 70s. Hats off to Grizzly Adams for coming in ten years later and addressing all of the unanswered man/ursine relationship questions.

1981 · Mercury

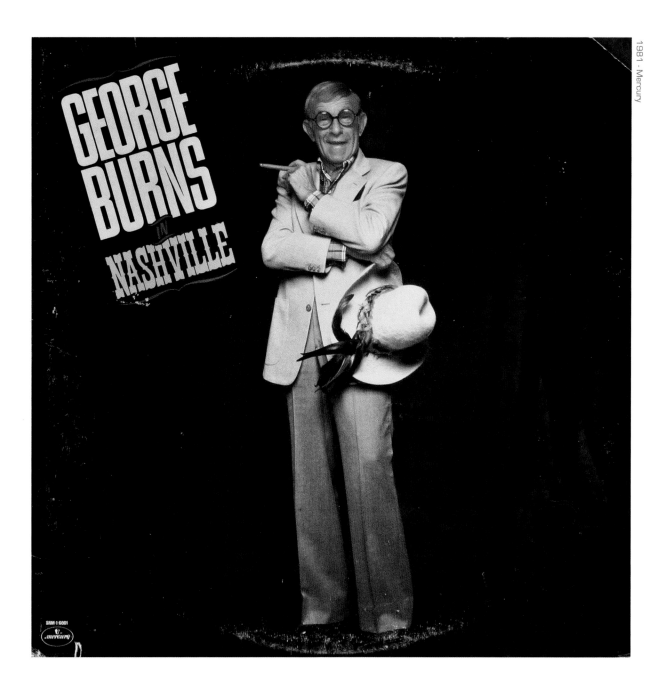

SRM-1-6001

mercury

GEORGE BURNS ─────── **George Burns In Nashville**

Later on in life, Burnsy was a dead ringer
for a frail Charles Nelson Riley. Not bad for
a guy born the same year Utah became a
state. Look it up.

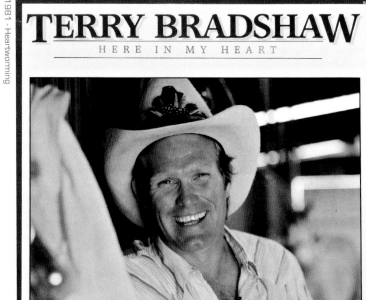

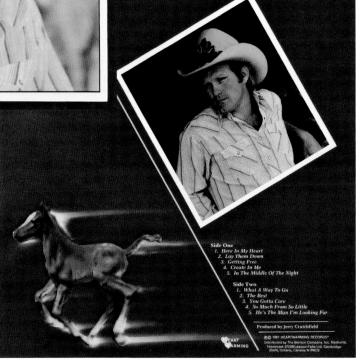

Side One
1. Here In My Heart
2. Lay Them Down
3. Getting Free
4. Create In Me
5. In The Middle Of The Night

Side Two
1. What A Way To Go
2. The Best
3. You Gotta Care
4. So Much From So Little
5. He's The Man I'm Looking For

Produced by Jerry Crutchfield

℗© 1981 HEARTWARMING RECORDS®
Distributed by The Benson Company, Inc. Nashville,
Tennessee 37228/Lawson Falls Ltd. Cambridge
(Galt), Ontario, Canada N1R6C9

TERRY BRADSHAW ——————— Here In My Heart

Ooooh. Look at Terry's lightning-fast horse on the back.
It looks sooo fast. Vroooom, horsey. Vroooom! Vroom
yourself right off this album. Then vroom over to Tony
Siragusa's house and trample his mouth.

80

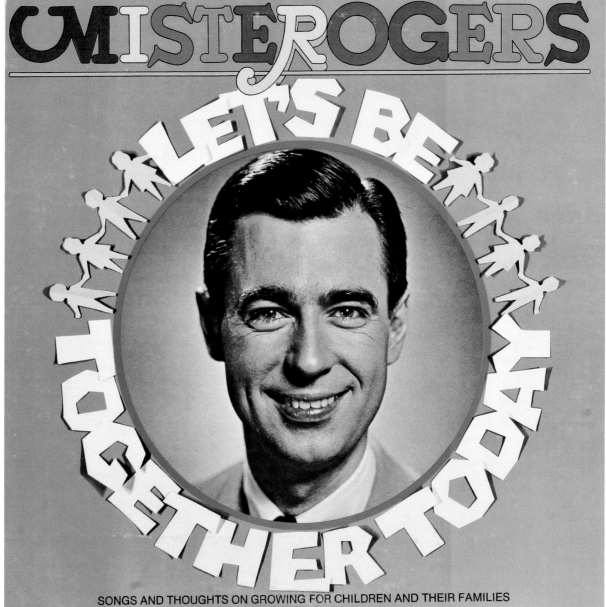

SONGS AND THOUGHTS ON GROWING FOR CHILDREN AND THEIR FAMILIES

MISTER ROGERS — Let's Be Together Today

Yes, let's be together today. And let's spend the day slicing bread on your hair. And not white bread. Pumpernickel. A nice, hard pumpernickel. Let's slice it on your hair. Yes, I do believe that this will be the best way to spend this day together.

THE COLONEL'S MANDOLIN BAND

Favorite Old Church Hymns Recorded For The Glorification Of Christ

Say what you will but I prefer Long John Silver's Favorite Old Church Hymns Recorded For The Glorification of Satan.

MONAURAL

Year Not Listed - Grant Enterprises

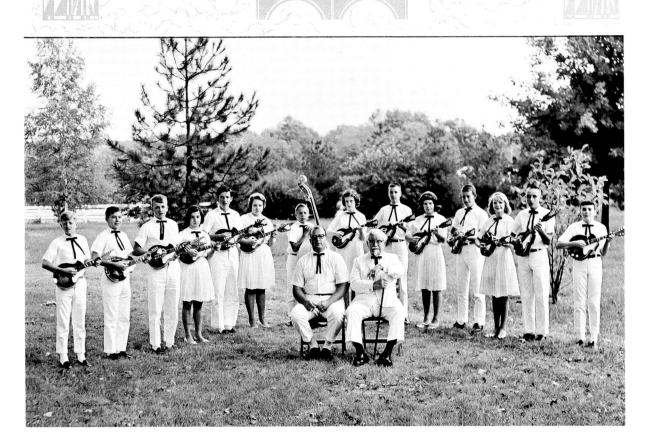

FAVORITE OLD CHURCH HYMNS

RECORDED BY

The Colonel's Mandolin Band

for the glorification of Christ

81

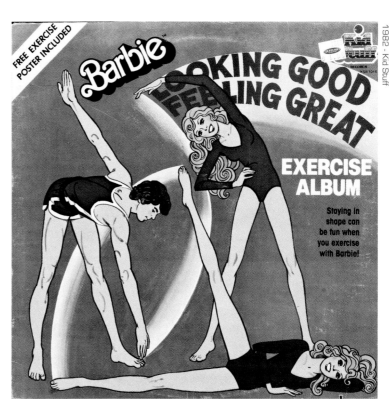

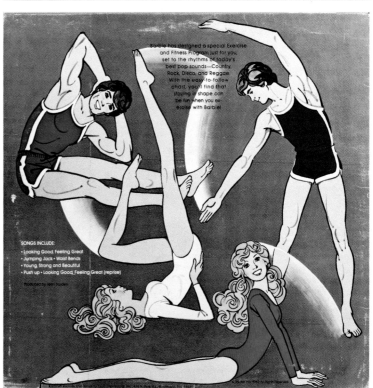

BARBIE — Looking Good. Feeling
Great. Exercise Album

Barbie – 12:22 a.m.

To: Ken
Bcc: Bela Karolyi
Re: Your Balls

Ken –

I saw your balls again today.
Please stop wearing those
blue shorts to class.

Hugs.

B

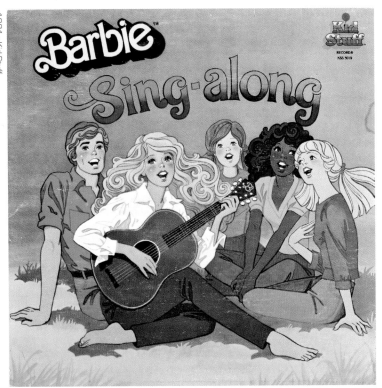

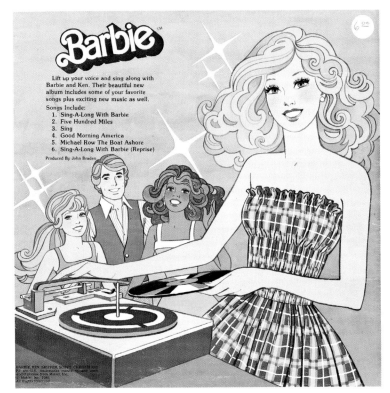

BARBIE — **Barbie Sing-along**

Barbie – 11:41 p.m.

To: Blonde Girlfriend,
 Redhead Girlfriend
Cc: Black Girlfriend
Bcc: Ken
Re: Party

OMG! You guys are totally invited to one of my famous Sing-alongs! It will be soooo fun, I swear. I totally want it to be better than the last one. I mean who does Strawberry Shortcake think she is? Over-dosing on my stash? At my dream mansion? WTF?!

If she is still all depressed because I showed Optimus Prime my bumps... I'll just die. GET OVER IT, BITCH!!!!

See ya Saturday. Somebody bring some Techno.

xoxo,
B

83

JOE PISCOPO

NEW JERSEY

1982 - Columbia Records

84

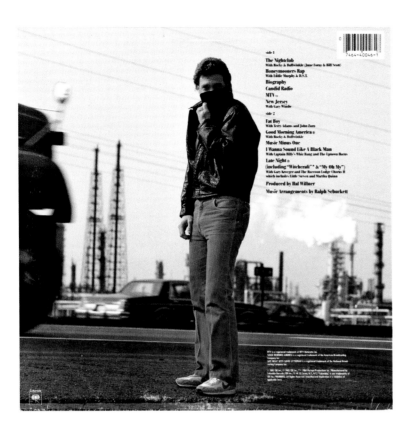

JOE PISCOPO ———— New Jersey

The Joe Piscopo Timeline:

- Saturday Night Live
- Miller Light Commercials
- Johnny Dangerously
- New Jersey
- TBD
- TBD
- TBD
- TBD
- TBD
- TBD
- Heart Attack

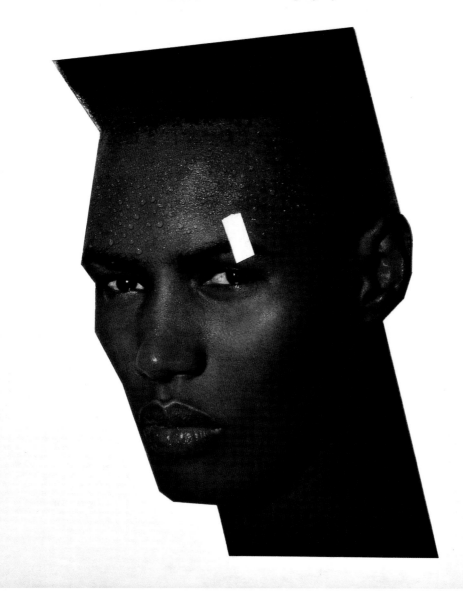

1982 - Island

86

GRACE JONES ———— Living My Life

My God, Carl Lewis. What happened to your eye?
Are you going to be able to compete in the long jump?!
It's a simple question, Carl. Are you going to be able to compete?!

Rappin' Rodney

I have nothing bad to say about the 6th funniest character in *Caddyshack*. My only critique of this album goes to the stylist. Is this supposed to be authentic? Am I supposed to be getting a street feel here? Last time I looked, Grandmaster Flash wasn't wearing a v-neck and Sir Edmund Hillary glasses. This is the kind of outfit that would have gotten someone killed on 110th Street in 1983. A red bandana AND a black bandana?!?! For Christ's sake, pick a side.

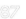

1983 - RCA

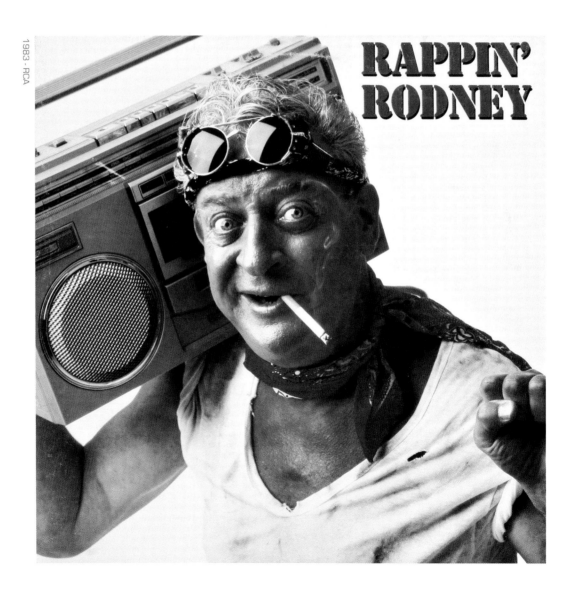

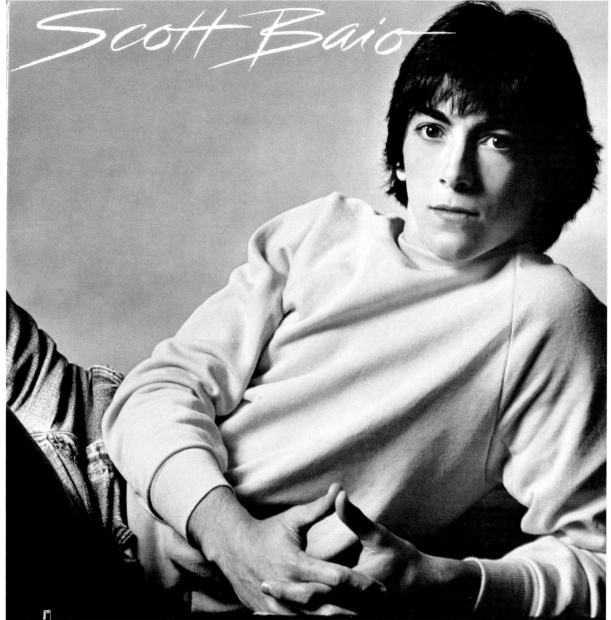

88

Scott Baio

SCOTT BAIO ———— Scott Baio

It's hard to criticize a man that had intimates
with Pam Anderson before Tommy Lee and
Hep B came calling but the corporate shill
factor on this album is just tragic. Is this
why Joni held onto her virginity for so long?
I think not.

What Was In That Kiss
Wanted For Love*
Woman, I Love Only You*
Half The World
Runnin' Out Of Reasons
 To Go
What Am I Supposed
 To Do
Looking For The
 Right Girl*
Midnight Confessions*
When You Find Someone
 Who Loves You
How Do You Talk
 To Girls*

•

Produced By
Bob Reno & Stephen Metz

Executive Producer
Nathan Lam

Arranged By
John Davis

*Background Vocals
Arranged By Jim Pike
And Sung By
Kevin McKnelly

Recorded At
Motown/Hitsville, U.S.A.
Hollywood, Ca
Recording Engineers
Guy Costa, Jane Clark
& Glen Jordan
Creative Director
Tony King
A & R Coordination
Marge Meoli

Photography & Art Direction
Glen Christensen

NFLI-8025

RCA

0 7863-58025-1

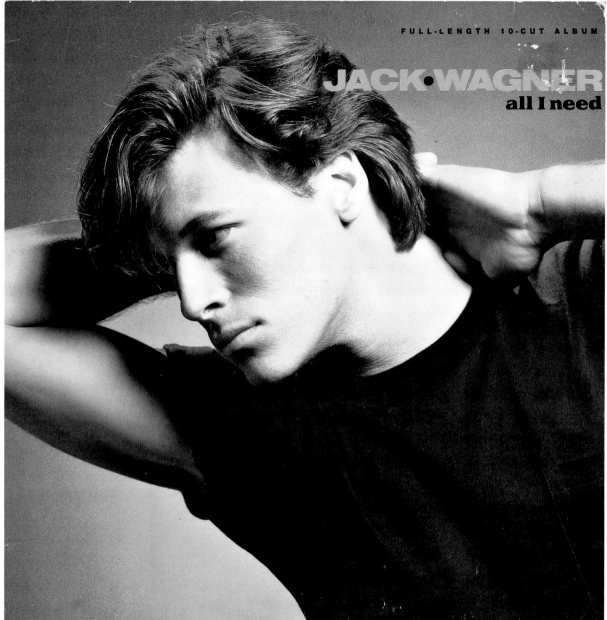

1984 - QWEST

FULL-LENGTH 10-CUT ALBUM

JACK•WAGNER
all I need

JACK WAGNER ———— **All I Need**

You are not prepared for the amount of mullet headshots available on justaboutjack.com. You may think you are, but you are not.

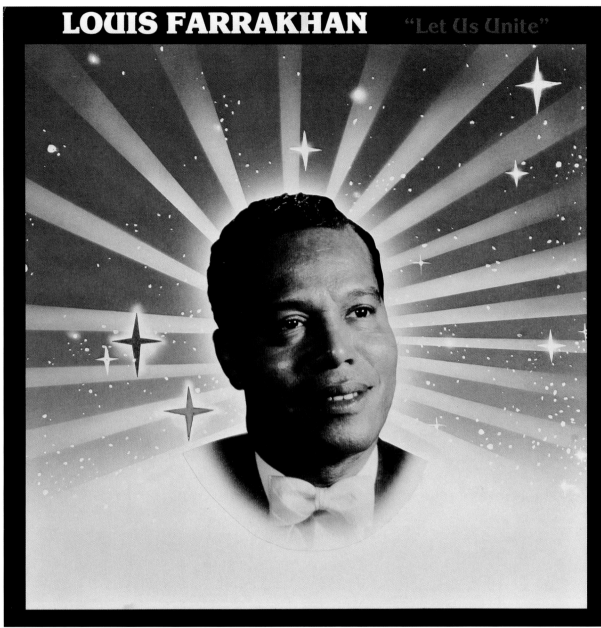

LOUIS FARRAKHAN ———————— Let Us Unite

If you can take one thing from
this album, it's the knowledge
that bow ties have the ability
to crush a human larynx.

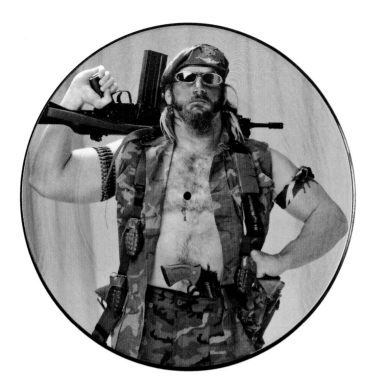

JESSE (THE BODY) VENTURA

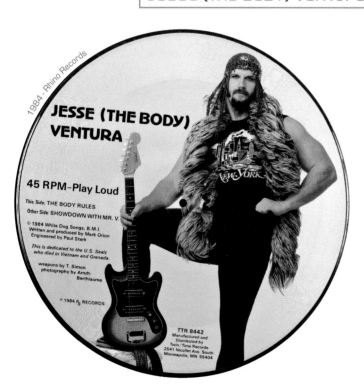

Jesse (The Body) Ventura

Quick, what's the greatest political movie of all time? *All the King's Men? Citizen Kane? Dave?* Nope. Nope. Nope. The greatest political movie of all time is *Predator.* No other movie can boast two governors (Schwarzenegger, Ventura) and one guy who ran for governor (Sonny Landham – the Native American guy with the maniacal laugh who slices his chest up with a knife and ultimately falls victim to Predator's deadly combination of invisibility and infrared sight). Ultimately, the only reason Ventura is better than both of these former politicians is this album and his brief stint as commentator for the XFL.

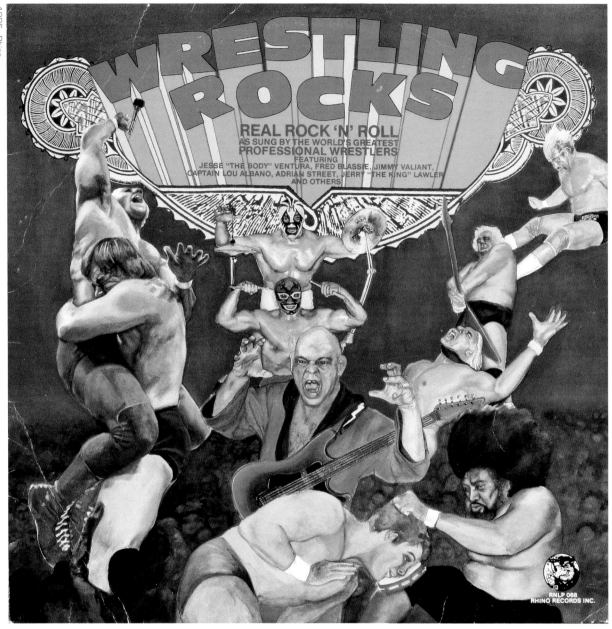

PROFESSIONAL WRESTLERS ——————— Wrestling Rocks

No, Wild Samoan! You're supposed to play the tambourine. PLAY IT. Damnit, how do we get through to your primitive ways?

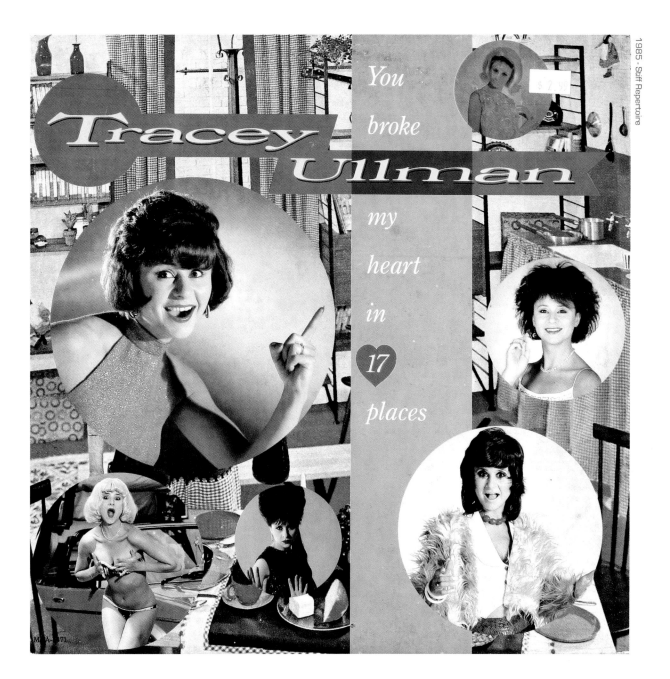

94

You broke my heart in ♥ 17 places

Tracey Ullman

TRACEY ULLMAN ——————— **You Broke My Heart In 17 Places**

I think Tracey Ullman is British.

All Because Of You

1985 - Sparrow

95

LISA WHELCHEL ———— **All Because Of You**

This bitch loved Jesus? Could have fooled me. Last time I looked she was mocking Jo's leather jacket and mullet. And I don't care what anyone says, I still blame her for burning down Edna's Edibles when she was a 200-lb, 32-year-old sophomore. That fire had inside job written all over it.

96

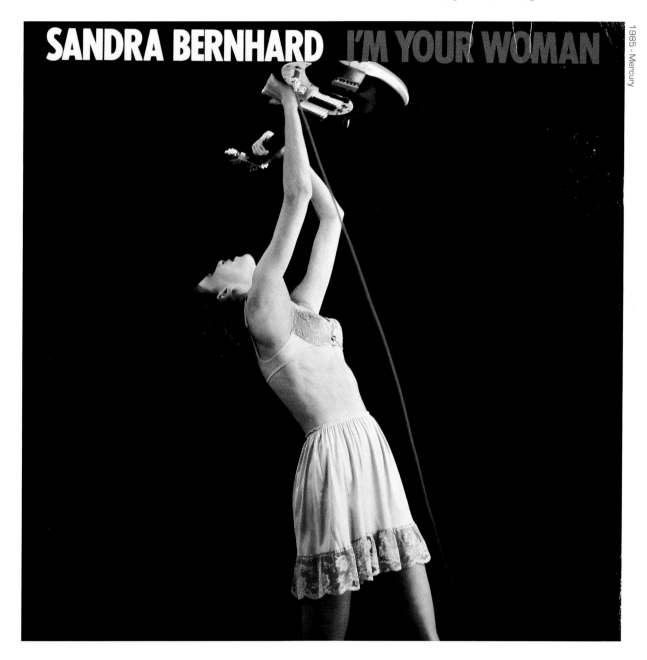

SANDRA BERNHARD I'M YOUR WOMAN

1985 - Mercury

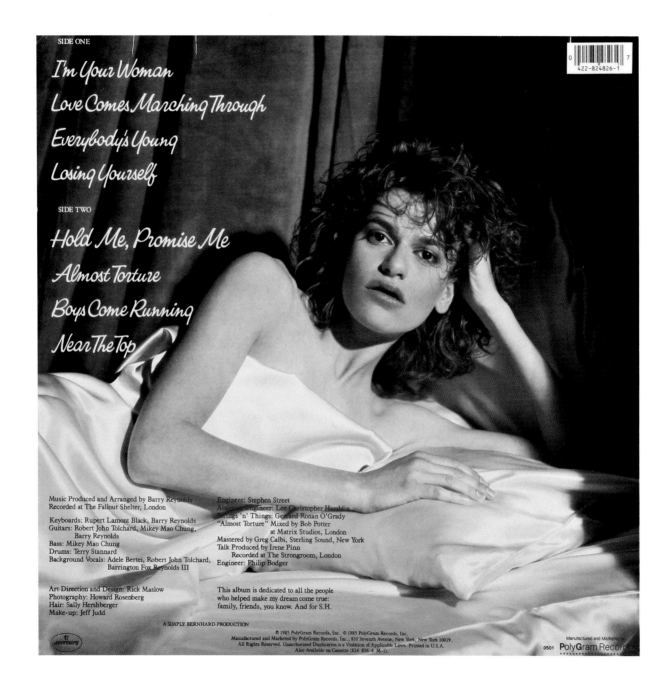

SIDE ONE

I'm Your Woman

Love Comes Marching Through

Everybody's Young

Losing Yourself

SIDE TWO

Hold Me, Promise Me

Almost Torture

Boys Come Running

Near The Top

97

Music Produced and Arranged by Barry Reynolds
Recorded at The Fallout Shelter, London

Keyboards: Rupert Lamont Black, Barry Reynolds
Guitars: Robert John Tolchard, Mikey Mao Chung,
 Barry Reynolds
Bass: Mikey Mao Chung
Drums: Terry Stannard
Background Vocals: Adele Bertei, Robert John Tolchard,
 Barrington Fox Reynolds III

Engineer: Stephen Street
Assistant Engineer: Lee Christopher Hamblin
Things 'n' Things: Gerard Ronan O'Grady
"Almost Torture" Mixed by Bob Potter
 at Matrix Studios, London
Mastered by Greg Calbi, Sterling Sound, New York
Talk Produced by Irene Pinn
 Recorded at The Strongroom, London
Engineer: Philip Bodger

Art Direction and Design: Rick Maslow
Photography: Howard Rosenberg
Hair: Sally Hershberger
Make-up: Jeff Judd

This album is dedicated to all the people
who helped make my dream come true:
family, friends, you know. And for S.H.

A SIMPLY BERNHARD PRODUCTION

0501 PolyGram Records

Manufactured and Marketed by

1985 - Motown Records

| BRUCE WILLIS | ——— The Return Of Bruno |

I have a soft spot for this album because it was the first album in my collection.
That being said, this is also the scariest album in my collection because Bruce
is still a viable actor. This album wasn't a last ditch effort to save a career.
To this day, he actually thinks people are interested in his harmonica stylings.
That's scary stuff. A friend told me that he once saw Bruce jamming on stage
with Kevin Bacon at the House of Blues. This is a lie.

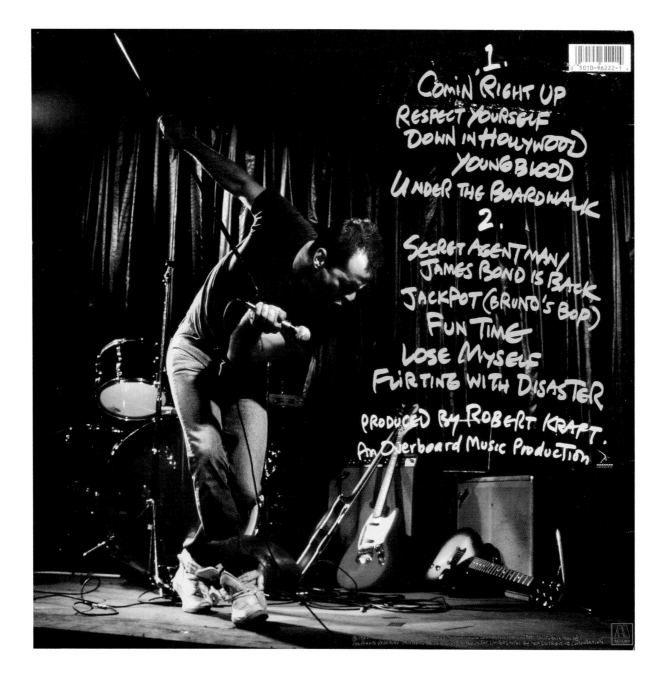

1.
Comin' Right Up
Respect Yourself
Down in Hollywood
Young Blood
Under the Boardwalk
2.
Secret Agent Man /
James Bond is Back
Jackpot (Bruno's Bop)
Fun Time
Lose Myself
Flirting with Disaster

Produced by Robert Kraft.
An Overboard Music Production

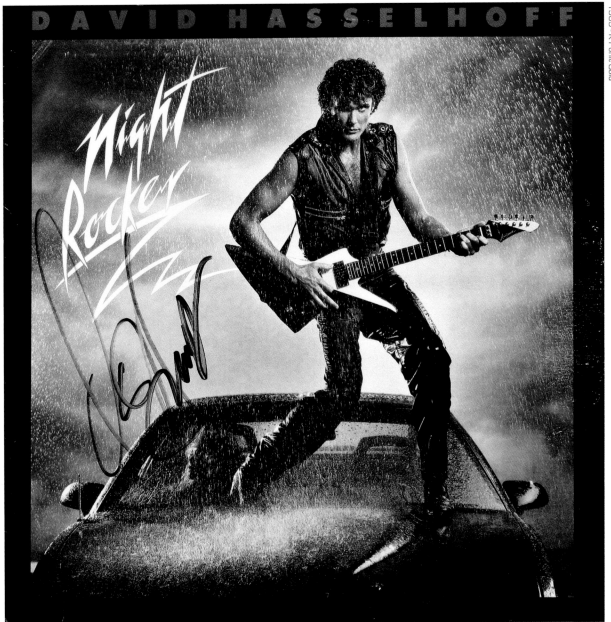

1985 - K Ponit Gold

DAVID HASSELHOFF ——————— Night Rocker

81 million Germans can't be wrong. Unless of course, it's
1938 and your last name is Weinstein. I will give the Germans
credit, though. When they embrace something, they embrace it
unabashedly. Unlike the Austrians, who just wait to see what the
Germans embrace and then copy it. I liken Austria to Steve
Sanders from *Beverly Hills 90210*.

Side One

Night Rocker

**Crazy On A
Saturday Night**

Do You Love Me

Our First Night Together
(with Catherine Hickland)

She Cried

Side Two

No Way To Be In Love
(with Catherine Hickland)

**Any Kind Of
Love At All**

All The Right Moves

No Words For Love

Let It Be Me
(with Catherine Hickland)

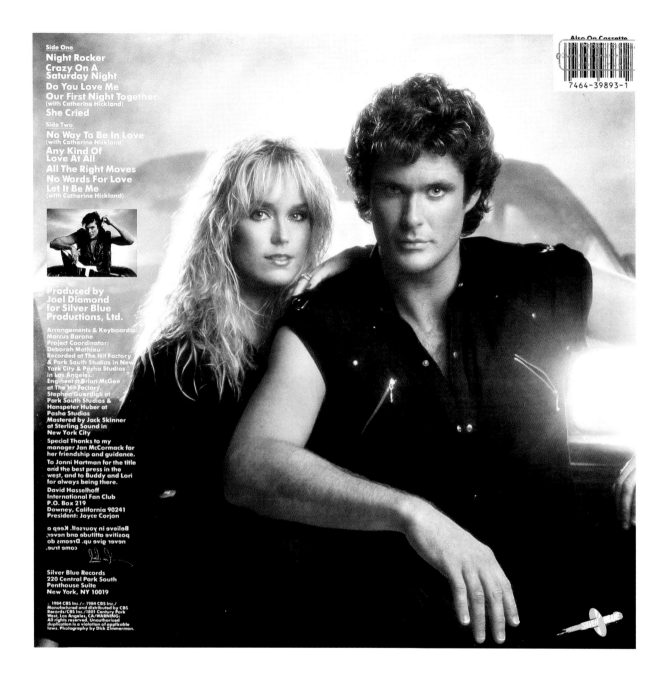

**Produced by
Joel Diamond
for Silver Blue
Productions, Ltd.**

Arrangements & Keyboards:
Marcus Barone
Project Coordinator:
Deborah Mathieu
Recorded at The Hit Factory
& Park South Studios in New
York City & Pasha Studios
in Los Angeles.
Engineers: Brian McGee
at The Hit Factory,
Stephen Guardigli at
Park South Studios &
Hanspeter Huber at
Pasha Studios
Mastered by Jack Skinner
at Sterling Sound in
New York City

Special Thanks to my
manager Jan McCormack for
her friendship and guidance.
To Jonni Hartman for the title
and the best press in the
west, and to Buddy and Lori
for always being there.

David Hasselhoff
International Fan Club
P.O. Box 219
Downey, California 90241
President: Joyce Corjon

Believe in yourself. Keep a
positive attitude and never,
never give up. Dreams do
come true.

Silver Blue Records
220 Central Park South
Penthouse Suite
New York, NY 10019

101

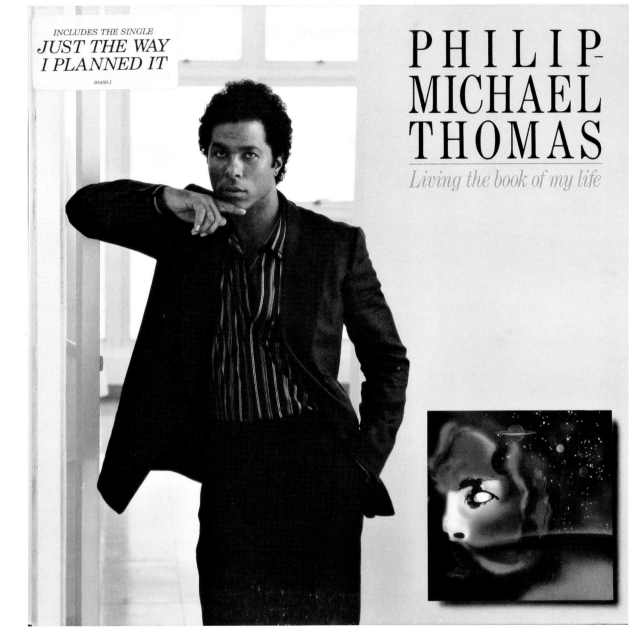

INCLUDES THE SINGLE
**JUST THE WAY
I PLANNED IT**

90486-1

PHILIP-
MICHAEL
THOMAS

Living the book of my life

1985 - SpaceShip

Side One
1. LIVIN' THE BOOK OF MY LIFE
2. JUST THE WAY I PLANNED IT
3. YOU MIGHT BE THE LUCKY ONE
4. FISH AND CHIPS (4:25)
5. EVERYTHING HAPPENS IN ITS OWN TIME

Side Two
1. GIVE A LITTLE
2. LET'S GET IT ON THE LOVE
3. I WANT TO MAKE LOVE TO YOU TONIGHT (5:35)
4. FLY AWAY
5. SEA BREEZE

EXECUTIVE PRODUCER: PHILLIP MICHAEL THOMAS
FOR P.M.T. MUSIC PRODUCTIONS, INC.

PRODUCED BY GEOFFREY CHUNG FOR PENURAH LTD.
AND P.M.T. PRODUCTIONS, INC.

PHILLIP MICHAEL THOMAS

Living The Book Of My Life

Well, well, well. What have we here? This album is like a little spy cam onto the *Miami Vice* set in 1986. There was no way that P.M. Thomas was just going to sit around while Don Johnson was stealing the thunder. Enter *Living the Book of My Life*. An R&B gem recorded out of jealousy and filled with all the believability of Tubbs's Jamaican accent in *Miami Vice's* pilot. As far as enjoyment factor goes, P.M. Thomas is one of my top five celebrity singers. A seamless addition to any BBQ or dinner party. Goes great with a Syrah.

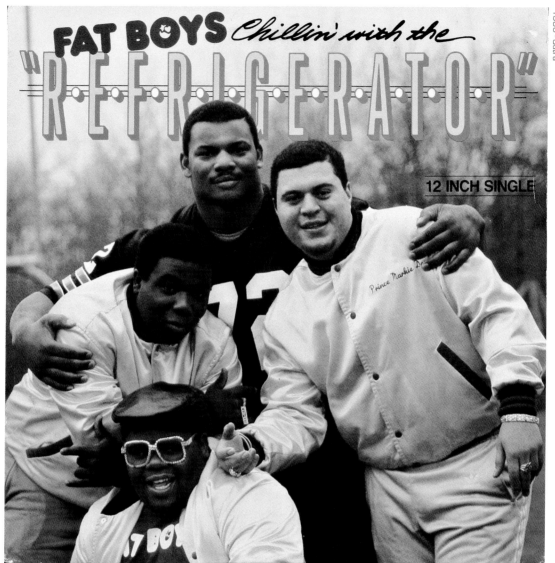

WILLIAM 'REFRIGERATOR' PERRY

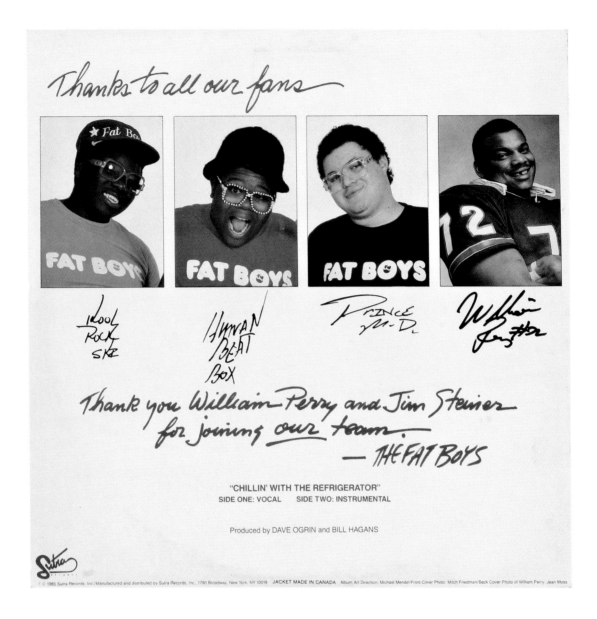

Thanks to all our fans

Kool Rock Ski

Human Beat Box

Prince M.D.

William Perry #72

Thank you William Perry and Jim Steiner for joining our team.
— THE FAT BOYS

"CHILLIN' WITH THE REFRIGERATOR"
SIDE ONE: VOCAL SIDE TWO: INSTRUMENTAL

Produced by DAVE OGRIN and BILL HAGANS

Sutra

Fat Boys Chillin' with the 'Refrigerator'

In 1987, Doug Pierce and I got a ride out to the mall to see The Fat Boys sing "Yo Twist" with Chubby Checker. They did not disappoint. And neither does this album. But listening to it always makes me wonder what it would be like if it were the other way around. What if Darren "Human Beat Box" Robinson (the one who looks like an Elton John/Star Jones hybrid) suited up with the Chicago Bears for a game? Could he stuff the gap with enough panache that Ditka might actually give him a shot at running the ball? And more importantly, could he become famous enough to score a meaningless, novelty touchdown in Super Bowl XX while the greatest running back of all time watched from the sidelines? Nice job, Ditka. Worst.

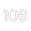

1985 - Atlantic

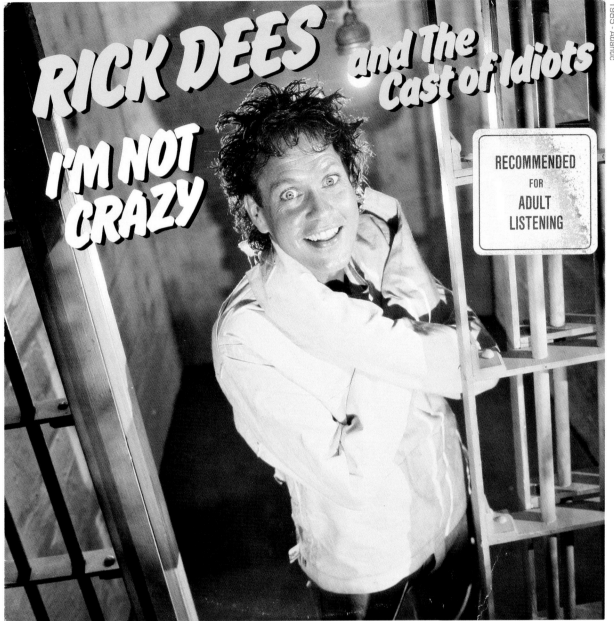

RICK DEES ——— I'm Not Crazy

Dees nuts.

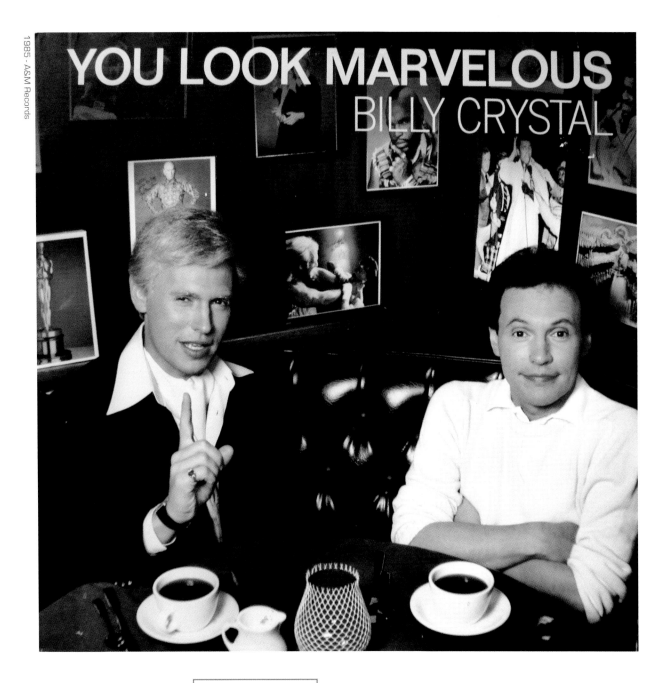

YOU LOOK MARVELOUS
BILLY CRYSTAL

107

BILLY CRYSTAL ———— You Look Marvelous

We love to deify the catch phrase, don't we? Sometimes we even demand a hobbled together song to drive the sensation home. Check out this little diddy on YouTube and suddenly a movie like *My Giant* becomes a lot more plausible.

108

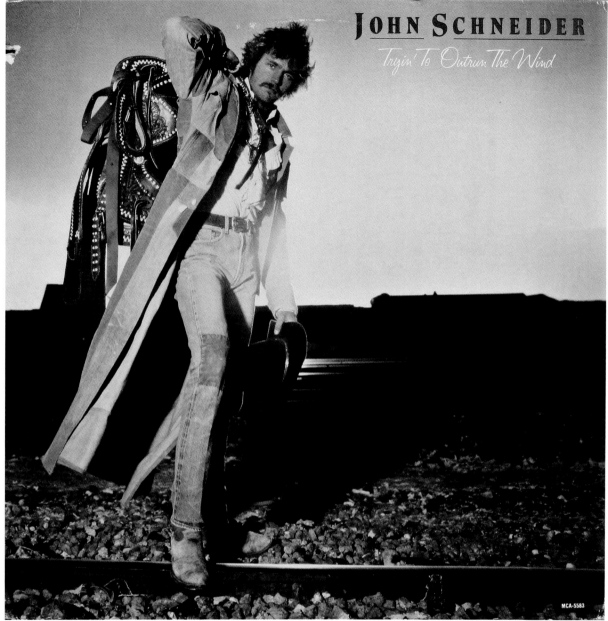

MCA-5583

JOHN SCHNEIDER ——————— **Tryin' To Outrun The Wind**

I'm tryin' to outrun the fact that I spent the better part of the
early 80s trying to blow up water towers with a bow and arrow.
You're dead to me, Bo Duke.

Take The Long Way Home
JOHN SCHNEIDER
≣DIGITAL

109

MCA-5789

JOHN SCHNEIDER ——— Take The Long Way Home

14 ball – corner pocket.
Z Cavaricci label – back pocket

EDDIE MURPHY ——— So Happy

Pluto Nashy

1986 - Columbia Records

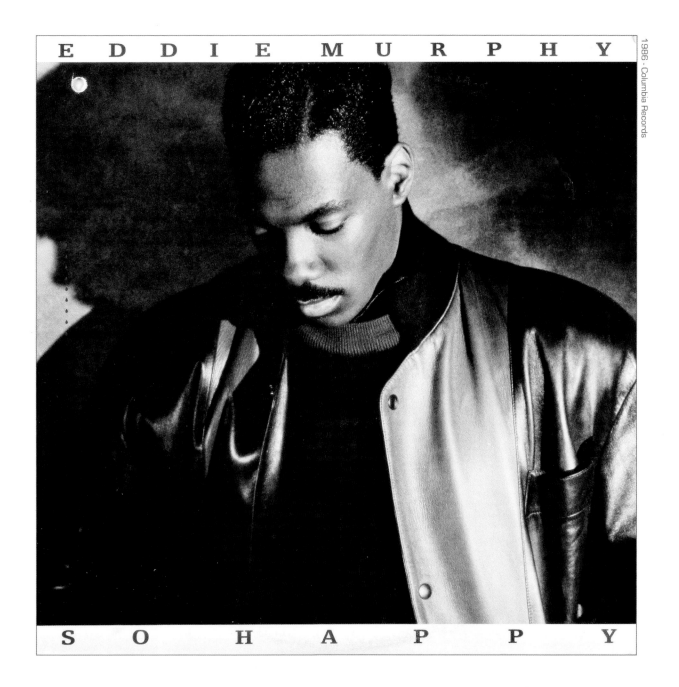

E D D I E M U R P H Y

S O H A P P Y

1986 - Columbia Records

EDDIE MURPHY
How Could It Be

EDDIE MURPHY ——————— How Could It Be

This title brings up a good question. How could this be? In 1985, Eddie Murphy could have taint-kicked Nancy Reagan on a daily basis and still been hailed as the next Pryor. He was that loved. And even though he found some commercial success with "Boogie in the Butt" and "Party All The Time" these albums don't really get interesting until you hear the love ballads. "I, Me, Us, We" is my favorite. It sounds like Captain Caveman getting disemboweled to a Ray Parker Jr. cover band. I thought surely we'd get a third album after he solicited a cross dresser. No dice.

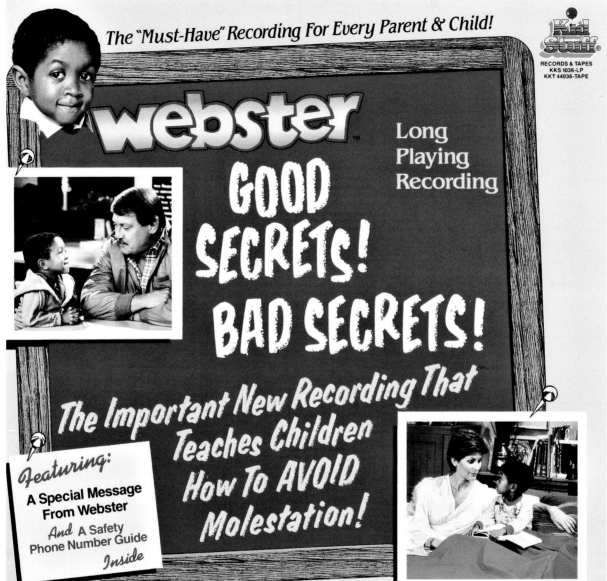

1986 - Kid Stuff

GOOD SECRETS! BAD SECRETS!

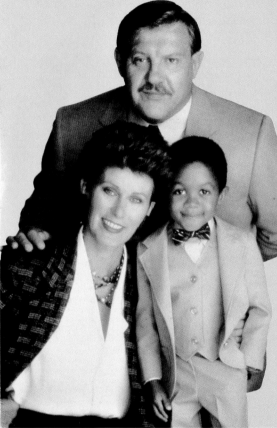

Message to Parents

With the sexual abuse of children seemingly on the rise, the need for increasing child awareness has become a top priority for all concerned parents. While today's mothers and fathers may live in fear of a child's coming home with a tearful account of "what that nasty person did to me," worse yet is the terror or shame locked within the victimized child who deems the incident a bad or "dirty" secret and does *not* tell his or her parents for fear of being blamed or called a liar.

Education in this area is vital, but the greatest impact on the child is achieved through peer identification. Certainly, Webster, a hero to millions of kids, is the ideal spokesman to deliver this message — to help children differentiate between good secrets and bad secrets and to learn how to handle themselves in potentially dangerous situations.

We urge you to listen to this story with your child or children and discuss with them afterwards the questions shown below. Then encourage them to read Webster's letter to them inside this jacket and help them fill out the emergency information they might one day need.

The Editors,
Kid Stuff Records & Tapes

- Why didn't Todd want to go to his sitter's house?
- Why didn't Todd tell his mother about his bad secret?
- What promise did Webster make to Todd? Why did Webster break that promise?
- What kind of touches are good touches? What kind are bad touches?
- Who are the people you can tell your secrets to?
- What kind of power did Webster and Todd learn they had?

WEBSTER ———— Good Secrets! Bad Secrets!

Sure *Diff'rent Strokes* had an episode where the Maytag Man tried to get into Dudley's pants at a bike shop. But did they make an album about it?! No. Enter Emmanuel Lewis — America's second favorite diminutive, black orphan. The only thing this album lacks is a musical rendition of "Show Me On This Doll Where He Touched You." Question: If you had to chose, who would you rather be molested by - George or Ma'am Papadapolis? One vote - George.

1986 - Warner Bros

THE CAST OF DALLAS

Dallas – The Music Story

Whoa, whoa, whoa. You're telling me that Patrick Duffy was in a show before *Step by Step*? And he may have been involved with his father's murder? I say bullshit. Suzanne Somers says bullshit.

RCA

Christmas Day

with
Colonel Sanders

I HEARD THE BELLS ON CHRISTMAS DAY Ed Ames	SANTA CLAUS IS COMIN' TO TOWN The Norman Luboff Choir
GOD REST YE MERRY, GENTLEMEN Chet Atkins	THE CHRISTMAS SONG (Chestnuts Roasting on an Open Fire) Henry Mancini and His Orchestra
WHITE CHRISTMAS Lana Cantrell	
I'LL BE HOME FOR CHRISTMAS Floyd Cramer	SILENT NIGHT Jim Reeves
PARADE OF THE WOODEN SOLDIERS Arthur Fiedler / Boston Pops	MEDLEY: WASSAIL SONG; DECK THE HALLS The Robert Shaw Chorale
IT CAME UPON A MIDNIGHT CLEAR Morton Gould and His Orchestra	MEDLEY: AWAY IN A MANGER; I SAW THREE SHIPS
RUDOLPH, THE RED-NOSED REINDEER Al Hirt	Hugo Winterhalter and His Orchestra and Chorus

Kentucky Fried Chicken®

SPECIAL COLLECTOR'S EDITION

COLONEL SANDERS ———— Christmas Day with Colonel Sanders

Gather round the slaves. It's time to burn
a yule log made of 11 secret herbs and
spices.

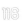

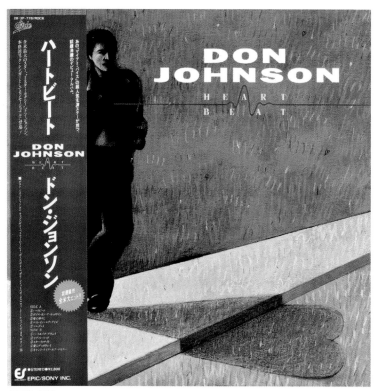

1986 - EPIC

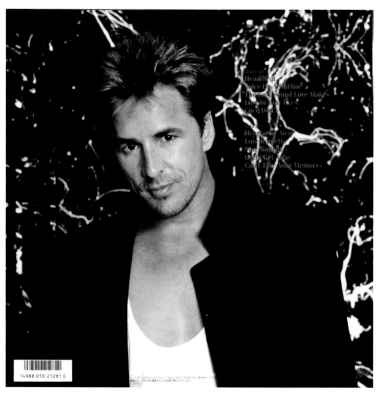

DON JOHNSON ————

Heartbeat

1986 - a good year for Crockett. He had the looks. He had the clothes. And he had a Top-5 single in the song "Heartbeat." Let me repeat that. He had a Top-5 single in the song "Heartbeat." That's nice. No wonder the Commies hated us. While Reagan was begging Gorbachev to tear down the wall, a nation of morons was begging DJ Tim to spin some *Nash Bridges*. Was anyone getting more action in the 80s than this guy?

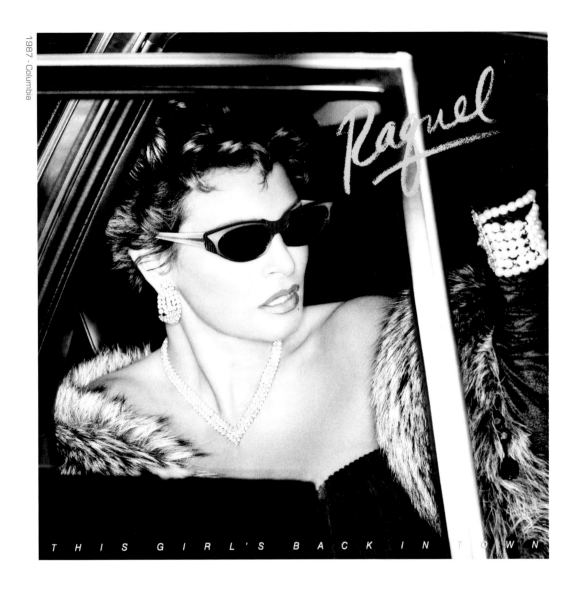

Raquel

THIS GIRL'S BACK IN TOWN

RAQUEL WELCH ——————— This Girl's Back In Town

It's true. This girl *is* back in town. Except she's not a girl anymore.
She's a 47-year-old cougar with two missing ribs and a possible
incontinence problem. Still interested?

1987 - Epic

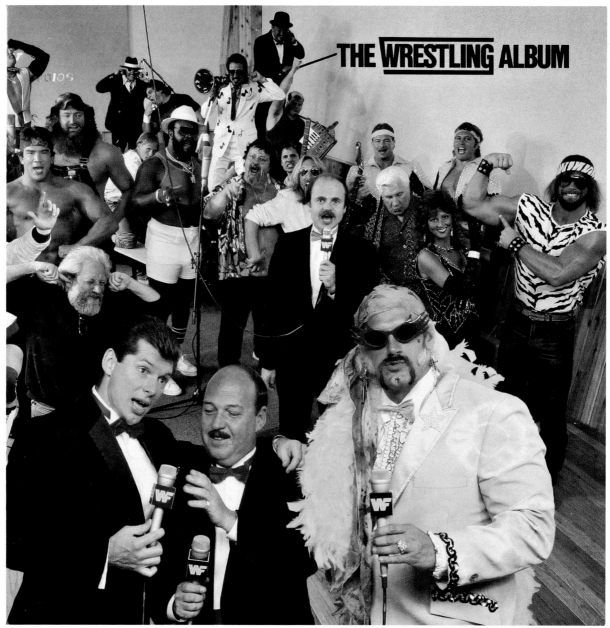

THE **WRESTLING** ALBUM

WORLD WRESTLING FEDERATION

The Wrestling Album

Why is Bobby "The Brain" Heenan checking out Miss Elizabeth's butt with Macho Man standing right there? Why is Junkyard Dog dressed like a shuffleboard pimp? And why does everybody have their back turned to Mr. Fuji? There's not a hospital in the country prepared for the amount of salt-to-the-eye cases it's about to see.

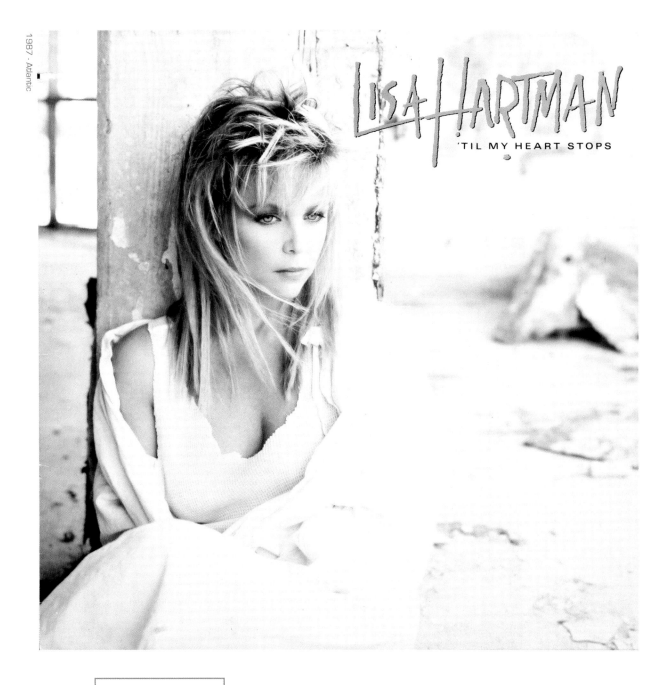

119

LISA HARTMAN ———— 'Til My Heart Stops

After visiting Lisa's website, I'm con-
vinced that she should have married
Jack Wagner instead of Clint Black.

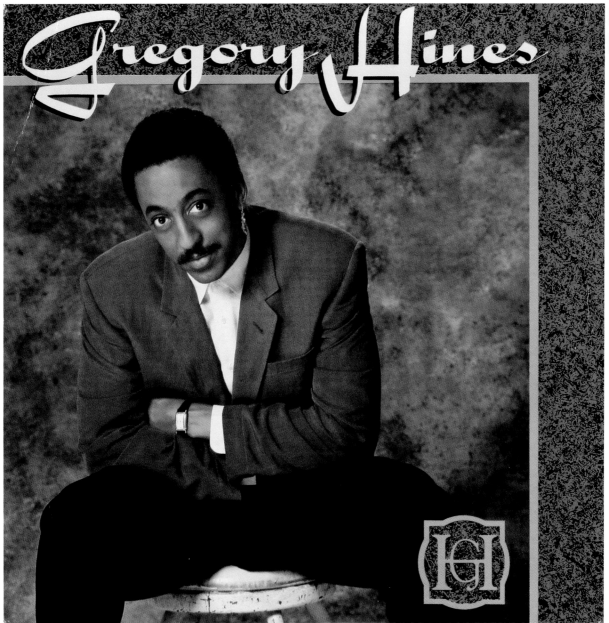

GREGORY HINES ──────── Gregory Hines

Tappaty tap tap. Tap tap crap.
Tappaty tap tap. Tap tap crap.
Tappaty tap tap. Tap tap crap.

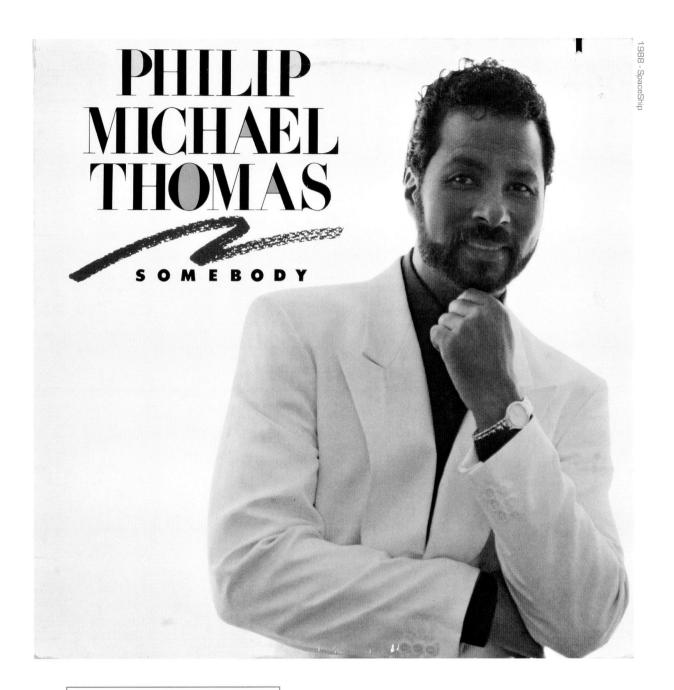

121

PHILIP MICHAEL THOMAS

SOMEBODY

PHILLIP MICHAEL THOMAS ——— Somebody

Here's an idea for a T.V. show. P.M. Thomas and Reginald vel Johnson are two retired cops in desperate need of some excitement. So what do they do? They open up a donut shop right across the street from their old precinct! The hijinks never stops in what UPN is calling this year's zaniest new comedy. Tune into *Back On The Force* Tuesdays at 9:00.

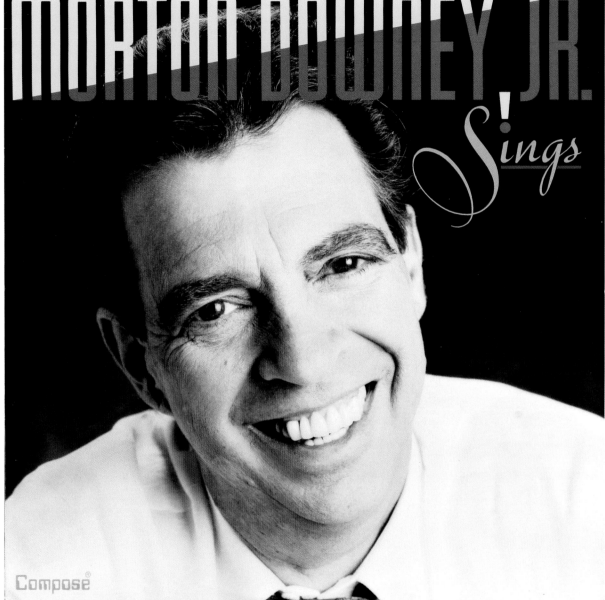

122

MORTON DOWNEY JR. ───────── Morton Downey Jr. Sings

This man started it all. He was Jerry Springer and Bill O'Reilly rolled into one. An intolerant circus act so desperate for attention that he once faked an attack in the San Francisco Airport by drawing a swastika on his face and shaving his own head. Remember when Rowdy Roddy Piper sprayed him with a fire extinguisher during Wrestlemania V? Step into Piper's Pit and you're gonna get bit.

DON JOHNSON

6·99
OUR PRICE
music

123

DON JOHNSON ——————— Let It Roll

Recorded fifteen years before Melanie
Griffith began to look like modeling clay.

THE SUPER BOWL SHUFFLE*
THE CHICAGO BEARS SHUFFLIN' CREW

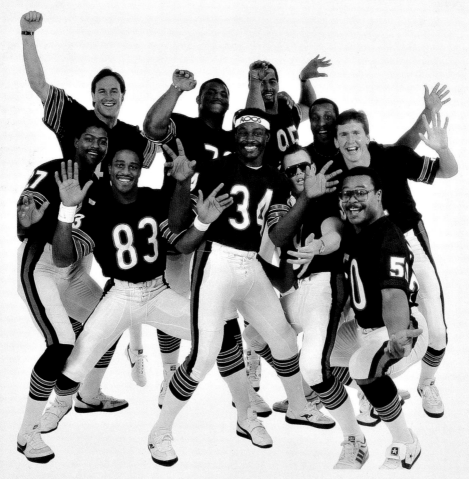

*A substantial portion of the proceeds from this record
will be donated to help feed Chicago's neediest families.

THE CHICAGO BEARS SHUFFLIN' CREW

The Super Bowl Shuffle

Based on this cover, I find it utterly fascinating
that Mike Singletary was once the most feared
player in the game. Those BluBlockers he's
wearing must drive Gary Hogeboom crazy.

125

SHAQUILLE O'NEAL ——— I'm Outstanding

Awesome title.
Worst free throw shooter ever.
Worst rapper ever.

126

THE VERY BEST OF *Marilyn Monroe*

MARILYN MONROE ——— The Very Best Of Marilyn Monroe

The very best of Marilyn Monroe?
Really? I think JFK might have something to say about that.

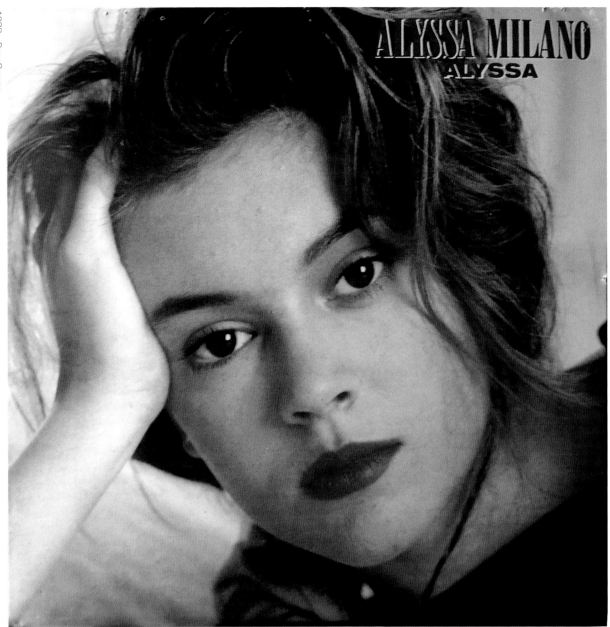

1989 - Pony Canyon

ALYSSA MILANO ——————— Alyssa

Anything spawned from Danza's loins deserves to be listened to.
Except for his semen. And this album.

This book is dedicated to *The Jeff Foxworthy Show*, *The Magic Johnson Show*, Michael Jordan's career with the Birmingham Barons, Reba McEntire's sitcom and all the parents out there who thought it would be a good idea to take the *Double Dare* physical challenge with their kids in 1986. Your efforts have not gone unnoticed.